EXTREME FACE PAINTING

50 FRIENDLY & FIENDISH STEP-BY-STEP DEMOS

BRIAN & NICK WOLFE

EXTREME FACE PAINTING. Copyright @2010 by Brian & Nick Wolfe.

Manufactured in USA. All rights reserved. No part of this book may be reproduced in any form or by any electronic or mechanical means including information storage and retrieval systems without permission in writing from the publisher, except by a reviewer who may quote brief passages in a review. Published by IMPACT Books, an imprint of F+W Media, Inc., 4700 East Galbraith Road, Cincinnati, Ohio, 45236. (800) 289-0963. First Edition.

Other fine IMPACT Books are available from your local bookstore, art supply store or online supplier. Visit our website at www.fwmedia.com.

17 16 15 14 13 9 8 7 6 5

Distributed in Canada by FRASER DIRECT 100 Armstrong Avenue Georgetown, ON, Canada L7G 5S4 Tel: (905) 877-4411

Distributed in the U.K. & Europe by DAVID & CHARLES Brunel House, Newton Abbot, Devon, TQ12 4PU, England Tel: (+44) 1626 323200 Fax: (+44) 1626 323319 Email: postmaster@davidandcharles.co.uk

Distributed in Australia by CAPRICORN LINK P.O. Box 704, S. Windsor NSW, 2756 Australia Tel: (02) 4577-3555

Library of Congress Cataloging in Publication Data

Wolfe, Brian, 1968-

Extreme face painting : 50 friendly & fiendish demos / Brian and Nick Wolfe. -- 1st ed.

p. cm.

ISBN 978-1-4403-0270-1 (alk. paper)

1. Face painting. I. Wolfe, Nick, 1968- II. Title. III. Title: 50 friendly & fiendish demos. IV. Title: 50 friendly and fiendish demos.

TT911.W65 2010

745.5--dc22

2010017861

edited by **Jennifer Lepore Brune & Layne Vanover**production edited by **Mona Michael**designed by **Jennifer Hoffman**photography by **Richard Deliantoni & Christine Polomsky**production coordinated by **Mark Griffin**

TO CONVERT	то	MULTIPLY BY
Inches	Centimeters	2.54
Centimeters	Inches	0.4
Feet	Centimeters	30.5
Centimeters	Feet	0.03
Yards	Meters	0.9
Meters	Yards	1.1

Metric Conversion Chart

ABOUT THE AUTHORS

Brian and Nick Wolfe have been painting faces professionally for twelve years. Influenced by comic books, movies, fantasy, fine art and anatomy, they perfected their craft in major theme parks, haunted attractions, fairs and festivals. Now their work appears in books, magazines, television and movies. The twins teach their art at trade shows, conventions and in private homes all around the world. They have studied techniques and theories behind the creative process, and new age, self-help and quantum physics books have influenced their philosophies. They are quick with a smile and find the good in everyone and every situation. They describe their workshops as spiritual healing classes with a facepainting gimmick and are the current world champion brush and sponge bodypainters. When they are home in Orlando, they are making costumes, playing heavy metal guitar, singing or partying with friends and family. They are extremely enthusiastic and eagerly share their ideas at eviltwinfx.com.

ACKNOWLEDGMENTS

BRIAN would like to thank his wife. Dara, and daughter, Trinity, for all their love and support. Big thank yous go out to the friends, family and all who believed in us and the magic and joy of face painting.

NICK would like to thank his family, friends and fans, who are responsible for this publication

CONTENTS

What Is Face Painting All About?	07
Materials	08
Techniques	10

18

Blue Jay

Bunny

DEMOS

Whether you're in the mood for something frightening or something more personable and cute, follow along, step by step, to create any character you can imagine!

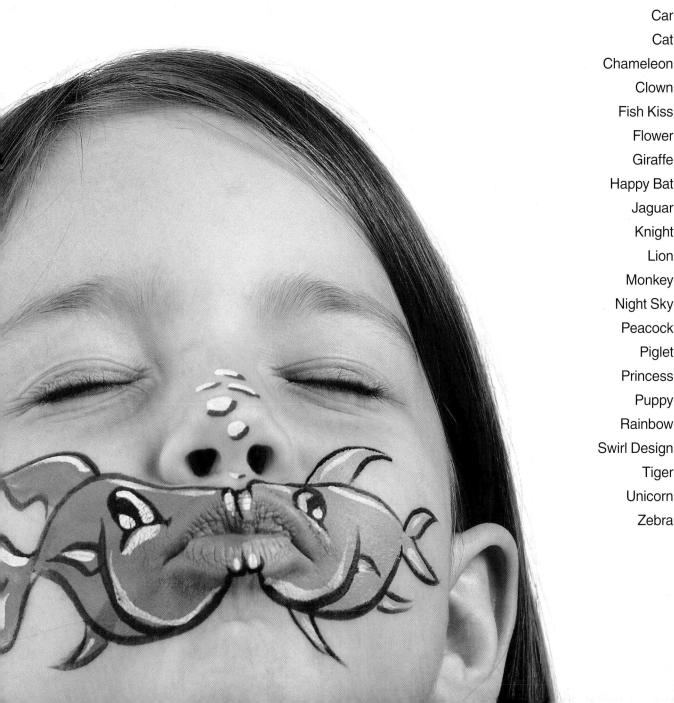

FRIENDLY FACES

Butterfly Car Cat Chameleon Clown Fish Kiss Flower Giraffe Happy Bat Jaguar Knight Lion Monkey Night Sky Peacock **Piglet Princess** Puppy Rainbow

> Tiger Unicorn Zebra

70

FIENDISH FACES

Alien

Bad Girl Mask

Beast

Cyborg

Dracula

Dragon

Fire Demon

Gargoyle

Goth Girl

Insect

Jack-o'-Lantern

Mr. Hyde

Mummy

Orc

Reptile

Robot

Skeleton

T-Rex

Werewolf

Widow Spider

Witch

Wolf

Xenomorph

Yeti

Zombie

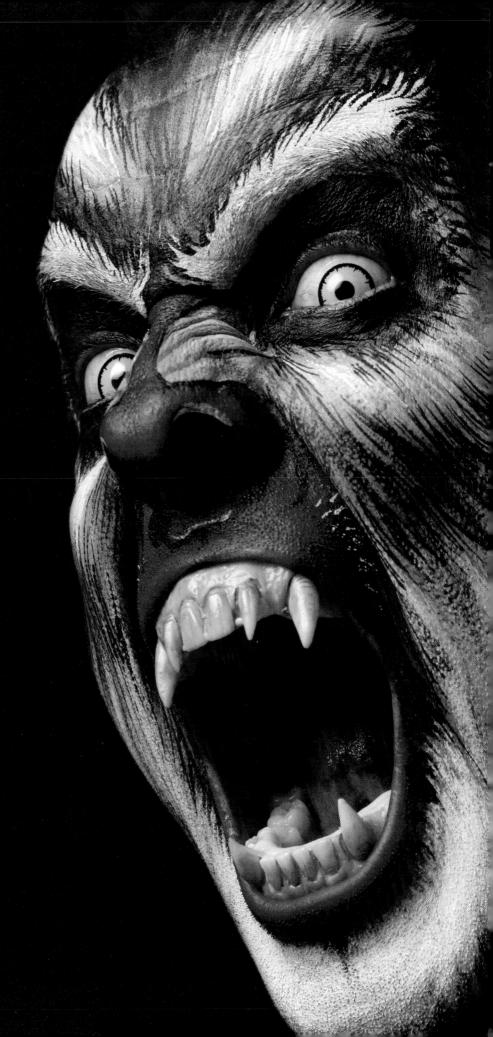

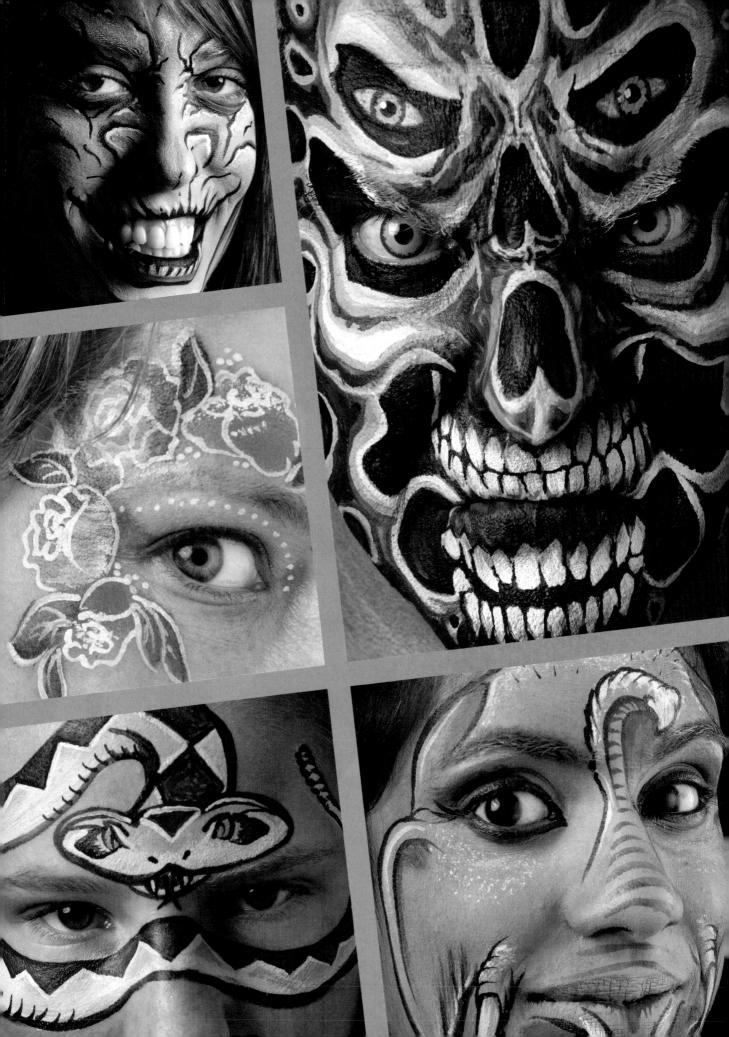

WHAT IS FACE PAINTING ALL ABOUT?

FACE PAINTING IS ABOUT INSPIRATION.

There is no bad face painting. The purpose of face painting is to make people happy. It takes an everyday person and taps into her heart's desire—to be a princess, or a tiger, or both.

When someone's face is painted, he may feel more noticed, accepted, praised, feared or loved. People who get painted act differently than they ever have before. They do more than wear the paint on their faces. They become that princess or that tiger. They are transformed.

Face painting is an art form that has no boundaries and is as original as the face that is painted. It is two-dimensional art put on a three-dimensional canvas that moves, sings, roars or laughs. Finally, face painting just makes people smile. And, after all, smiles are what we need most in this world. So face painting is really one of the most important jobs on the planet in our opinion.

This book was created to make more smiles, and most important, more smile makers!

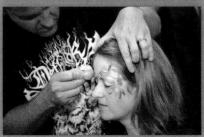

MATERIALS

You don't need a ton of stuff to get started painting faces. Brushes and paints are the essentials.

Paint Allergies

Rarely is anyone allergic to face paint. Allergies will usually result in discomfort within a minute or so of application. If this happens, wash off the paint with soap and warm water and discontinue use. We have painted hundreds of thousands of faces from all over the world and have never witnessed a reaction, but it could happen.

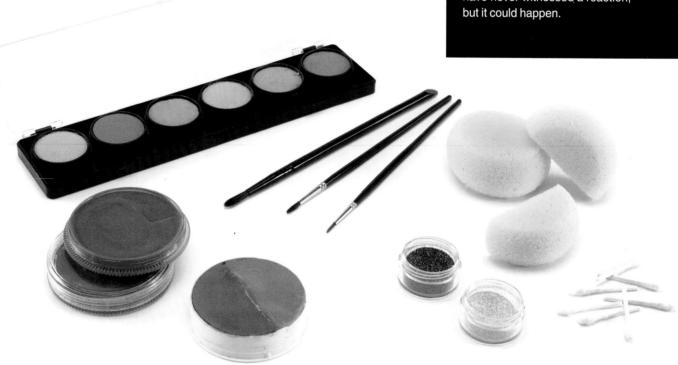

PAINTS

Use water-based theatrical makeup that is hypoallergenic and nontoxic. Acrylic paint is not made for face painting and should be avoided. Every brand of face paint works. Some have more pigment and brighter colors, while some are easier to wash off. Decide which characteristic is more important to you and go with that.

BRUSHES

We use small synthetic rounds. Make sure they have stiff bristles with sharp points that can yield a fine line. Stick with a no. 3 round for ideal control. The bigger the brush size, the less control you'll have, which means the lighter your touch will need to be. A no. 3 round allows you to make a really thin line and by applying more pressure, you can produce a wide line as well. If you find your linework is a bit heavyhanded, try a no. 1 round. Use a no. 6 round for very wide lines. All these brushes can be found in any art or craft store.

OTHER MATERIALS

Cotton swabs cut in half are useful as disposable applicators, erasers (when used with a little water) or disposable brushes. You'll also need sponges. We recommend firm sponges with rounded edges and large pores. The sponges used for this book are pottery sponges cut in half. Hand sanitizer, baby wipes and loose polyester glitter are also great items for your kit.

SPLIT PAINT CAKES

Split cakes have both the dark and light shades of a color. Some have one half UV-reactive (black light) paint. The idea is to have more color choices in a smaller kit and to be able to mix colors to achieve maximum coverage and the brightest color. Colors can be mixed right on top of the cake as well. Wipe the cake clean with a baby wipe to get it back to the original condition.

FACE PAINTING KIT SETUP

All face painting kits are unique, but this is our typical set up. One color per sponge is recommended. Use one end for the paint and keep one end dry for blending.

USING SPONGES

Wet only the very tip of the sponge. The amount of water determines how much paint there will be to work with. If you wipe a sponge across the cake a few times, the makeup will be thin, watery and transparent. Rub the sponge many times and the makeup becomes thick and opaque.

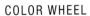

Make yourself a simple color wheel to help you choose colors. Colors on the same side of the color wheel blend easily—for instance, yellow, orange and red. Yellow is often used to highlight because it is brighter. To paint a green ball, for example, use blue for shade and yellow to highlight.

Another way to change the value of the base color is to add black (for shade) or white (for highlight). You can also create highlights by adding white to an adjacent color on the wheel. For example, to highlight purple, use light blue or light red.

SPONGE TECHNIQUES

The sponge is used to cover the face quickly with thin amounts of paint. Twisting the sponge in different directions can really add detail. Always test a sponge first to see how wet the paint is that's on it. It may have plenty of paint and water from the last face you painted. The sponge is a very versatile tool, so don't be afraid to use it a lot. Practice and pay attention to what you do and what the results are.

STIPPLING

This is one of the most useful sponge techniques. Stippling is great for blending color, suggesting texture, indicating highlights and suggesting facial hair. To get the most realistic result, hold your half sponge upside down so the rounded part touches the skin. Using the edge of the sponge would result in lines—something you want to avoid when stippling.

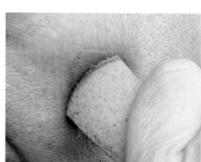

STIPPLING TO SUGGEST FACIAL HAIR Lightly tap the sponge in an even pattern.

CIRCULAR STROKES

Circular strokes can be used for cheek art and sectioning off parts of the face. A rounded sponge is perfect for this. The sponging doesn't have to be perfect; just try to make it as close as possible. The edges can be corrected with a brush later.

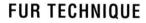

Use the fur technique to create striation patterns not only for fur textures. but also for muscle patterns and creature textures. If executed correctly, you can create a lot of detail quickly.

MAKING CIRCULAR STROKES To make a circular stroke with your sponge, simply apply the end of the sponge to the face and spin.

CREATING FUR
Fill your sponge with paint, then pull it in a downward motion across the face. Then, go back in with a second color, lightly dragging your sponge over the basecoat to indicate more texture.

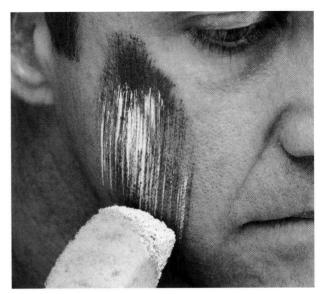

PAINTING LINE STROKES
Use the edge of your sponge to place line strokes.

DRAGGING COLOR
Pull color by dragging with the end of your sponge out from the paint.

BLENDING COLOR
Blend colors with the clean end of your sponge.

ADDING DOTS

Make dots with the corner of your sponge.

BRUSH TECHNIQUES

When painting lines, pretend your brush is dancing. The more fluid and confident your brushstrokes are, the more pleasing the design will be. Practice your linework often. Use your arm or thigh to warm up on and try new techniques. Hold the brush like a pencil and close to the end for more control. Sometimes, it helps to use your pinky finger to steady your hand. Nice linework can really save sloppy sponge work.

Remember, he who paints most, paints best. To become a quick and accurate painter, practice and focus!

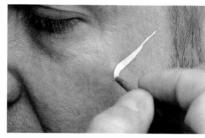

1 Beginning Thin to Thick
Begin the brushstroke before your brush meets
the skin. Then, gently touch the tip of your
brush to the face, gradually applying more
pressure toward mid-stroke.

PAINTING THIN TO THICK TO THIN LINES

Using this type of line (right) gives your face paintings style and depth, not to mention they will look fancier.

DRAWING STARS

Add stars (below) to your face paintings to give you extra flare or excitement. Whether painting a five-pointed star or a starburst, creating the perfect shape is all in the wrist. Simply flick your brush lightly, stroke by stroke, to create any star shape you desire.

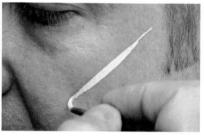

2 Finishing Thick to Thin
Once the thickest part of the line has been laid
in, slowly begin picking your brush up off the
skin as you move toward the end of the stroke.

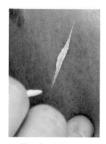

1 Beginning the Star Place your brush on what will be the center point of the star and flick a line down.

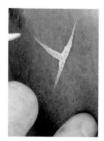

2 Adding the Second Stroke Flick your brush to the left.

3 Placing the Third Stroke Next, flick your brush to the right to form a cross.

4 Developing the Star Fill in your star with more small flicks radiating from the center.

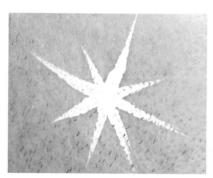

5 The Finished Result
By beginning in the center and working out,
your stars will look as though they are bursting and exploding with energy.

PAINTING SWIRLS AND CURLS

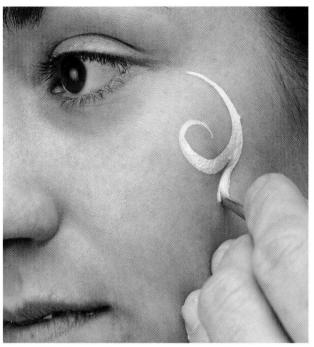

1 Beginning Swirls and CurlsPress your brush down toward the face when drawing the thickest part of your swirl or curl.

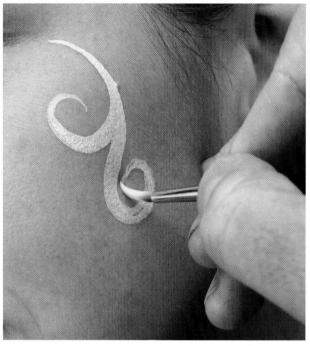

2 Finishing Swirls and Curls Conversely, apply barely any pressure at all when drawing the thinnest part.

PAINTING RAINDROPS AND TEARDROPS

1 Beginning Raindrops & Teardrops Create the thin point of the drop, applying light pressure with the tip of your brush.

2 Finishing Raindrops & Teardrops Gradually increase pressure and flatten the brush as you move toward the thicker end of the drop.

How to Remove Paint To remove face paint, use any of these items: COLD CREAM LOTION BABY SHAMPOO BABY OIL BABY WIPES Massage any of these into the face, then wipe it off immediately. Use eye makeup remover to get off any paint placed around the eyes.

PAINTING EYES

The design of the eyes is the most important part of the look of the characters you paint. Is your dragon supposed to be scary or cute? It all depends on the eyes. They are what everyone will look at first.

Your hand or arm is a good place to practice your painting.

1 Beginning a Cute Eye
Draw a small arch to indicate the cheek. Place a larger arch above the small one to suggest the eye.
Connect the end to the small arch.

2 Building a Cute Eye Add a thick half arch inside the eye for the iris.

3 Adding Cute Eyelashes Add three thick-to-thin strokes at the corner of the eye to lay in the eyelashes.

4 Finishing a Cute Eye Add white highlights to the cheek and the whites of the eye.

1 Beginning a Mean Eye Paint a sideways S-shape for the eyebrow.

2 Building a Mean Eye Add an almond-shaped eye beneath the brow.

3 Shading the Eyebrow Add shadows beneath the brow and the eye.

4 Finishing a Mean Eye Fill in the eye with white.

COTTON SWAB TECHNIQUES

Inexpensive and disposable, cotton swabs are valuable tools to have around.

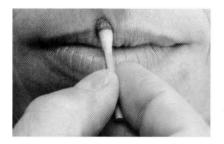

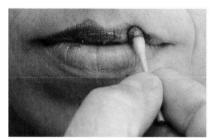

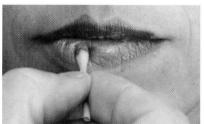

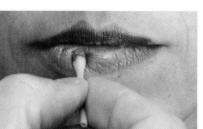

APPLYING PAINT TO LIPS Using a cotton swab on lips is less ticklish and gives the artist a more sanitary approach than using a brush. After the lips are painted, you can throw away the swab.

There really isn't any erasing in face painting. "Mistakes" are integrated into the design using glitter for girls and blood for boys. If you need to clean up edges or lift out some color, dip a cotton swab in water and apply it to the spot. To clean up drips, however, wipe the skin with a moist towelette or tissue.

ERASING MISTAKES

LAYING IN DOTS Dots made with a swab tend to be more consistent. If you need your dots to be the same size (like the rivets on a helmet), definitely use a cotton swab.

Cuts and Blemishes

If a model has any cuts or blemishes, use a cotton swab to paint around the wound without contaminating your brush or sponges. Bad sunburn, eczema, chicken pox sores and cold sores, etc. should always be avoided as the makeup may irritate the skin further.

MORE IMPORTANT TECHNIQUES

Here are a few more techniques good to have in your repertoire as you begin painting faces.

CREATING FUR TEXTURE

To suggest fur using your brush, flick the brush back and forth using the thin to thick to thin line technique. Paint in short, quick strokes for the best results. This is the technique used for moustaches, beards and animal fur.

SPATTERING

Spattering can be used for texture on rocks, for stars in outer space, as freckles, or as blood spraying from a wound. Using your brush, flick paint from a card aimed at the area you want to spatter.

MOTTLING

Mottling is painting random squiggles and dots to break up a smooth paint job and make something appear more textured. We use this a lot with zombie skin and monsters. It adds dimension and detail. Use the side of your brush to add wiggly strokes for mottling in texture. The brush shouldn't be too wet and the paint should be thinned.

APPLYING A WASH

Place a dab of paint in your palm, then water it down to create a thin consistency. Washes work well for shadowing beneath objects, making them pop off the face.

APPLYING GLITTER

Dip the end of a round brush in glitter and roll it onto wet paint.

SHADING AND OUTLINING

Shading and outlining are the basic painting skills that are good to master as you paint the projects. Practice with a simple sphere.

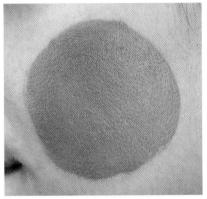

1 Establishing the Basic ShapeApply a basecoat in the shape of the object you wish to portray.

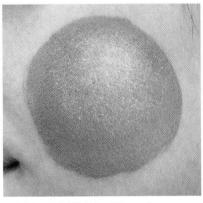

2 Adding Highlight for Dimension
Apply the highlight thickly in one small spot.
Then stipple the color out from the bright
center, overlapping the highlight.

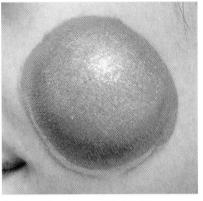

3 Place Shadows and Highlights
Apply a darker shade toward the bottom of the sphere, leaving a little line of the midtone to represent reflected color. Then, apply white to the very center of the yellow highlight, and add a white highlight on the reflected color at the bottom of the sphere.

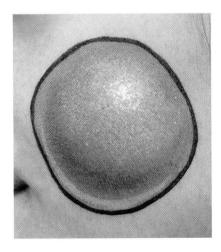

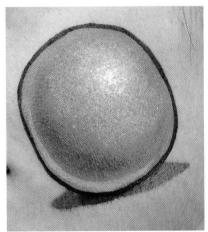

4 Outlining the Shape

Outline the sphere using a brush. When outlining, don't look at the tip of your brush. Rather, look at the object you are outlining and let your eye trace the outside. Your brush will automatically follow your eye.

When you finish a stroke but need to keep the outline going, don't start a new stroke at the end of the finished stroke. Instead, overlap the strokes so the line is consistent.

Adding a dark shadow underneath the sphere makes it appear to be resting on a surface.

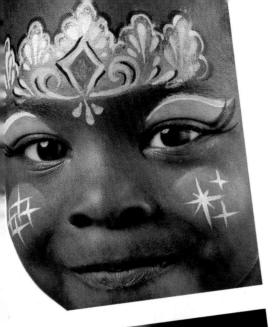

FRIENDLY FACES

Blue Jay

1 Using a sponge, apply a white basecoat beneath the eye and along the left cheek to suggest the white feathers.

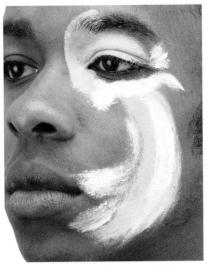

2 Add a light blue basecoat around the white areas with a sponge to suggest the light blue feathers.

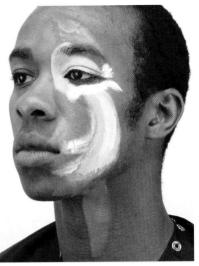

3 Apply blue around the white and light blue areas, fleshing out the shape of the bird and suggesting the darkest feathers. Stretch the tail feathers down the neck.

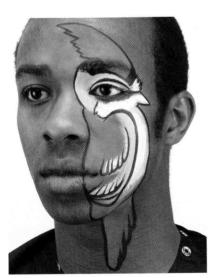

4 Outline the bird's body and wing in black using a no. 3 round. Begin detailing feathers on the wing using the same brush and color.

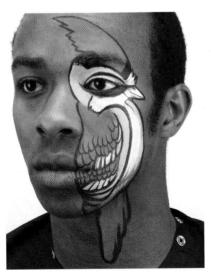

5 Continue to develop the feather lines and define the beak with a no. 3 round and black. Also shade down the tail, lightly dragging black strokes into the blue.

Then, with a no. 3 round and some blue, add more details and clean up the edges of the sponged areas.

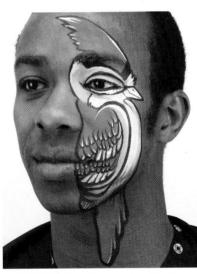

6 Add highlights to the crown and feathers of the bird by placing thin white lines and small white dots directly along the existing black outlines using a no. 3 round. Also use the white to clean up any sponged areas needing harder edges.

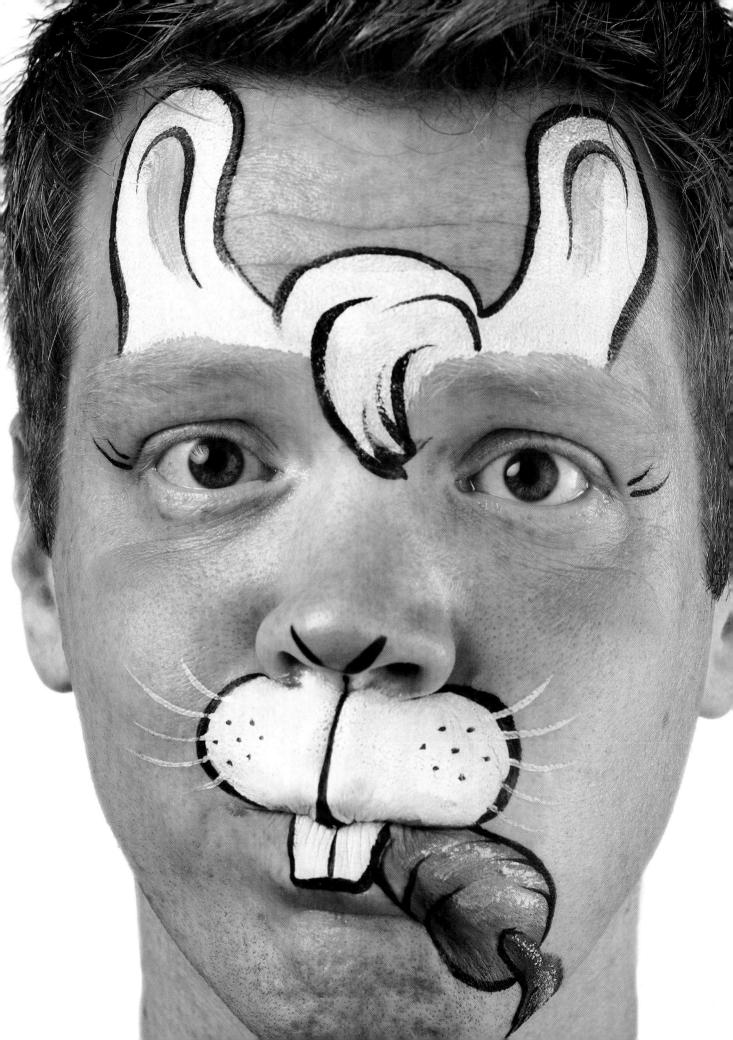

Bunny

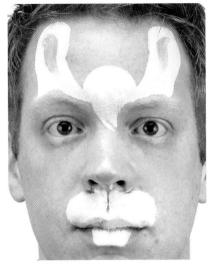

1 Using a sponge, apply a white basecoat to the mouth, ears and teeth, leaving a sliver of skin unpainted at the philtrum (the groove in the lip). Then apply pink to the tip of the nose and the insides of the ears.

2 Load a sponge with orange and paint the carrot at the left side of the bunny's mouth. Wipe out a small section of color at the top of the carrot and add in the leaves using green.

3 Add yellow highlights to the orange and green of the carrot using a sponge. Also shadow the carrot with a touch of brown. Then, place white highlights on top of the yellow highlights for added dimension.

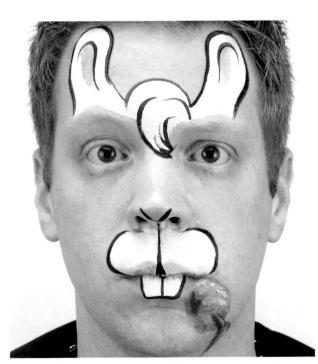

4 Outline the white face shapes and detail the lock of hair at the forehead with black using a no. 3 round.

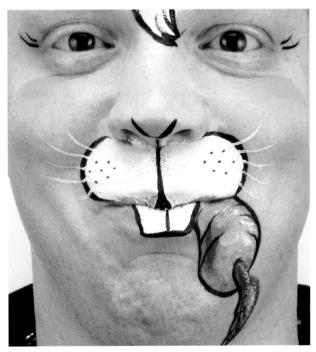

5 Dot in whisker spots, add eyelashes, and place details on the carrot using a no. 3 round and black. Add pink rosy cheeks and white whiskers using the same brush.

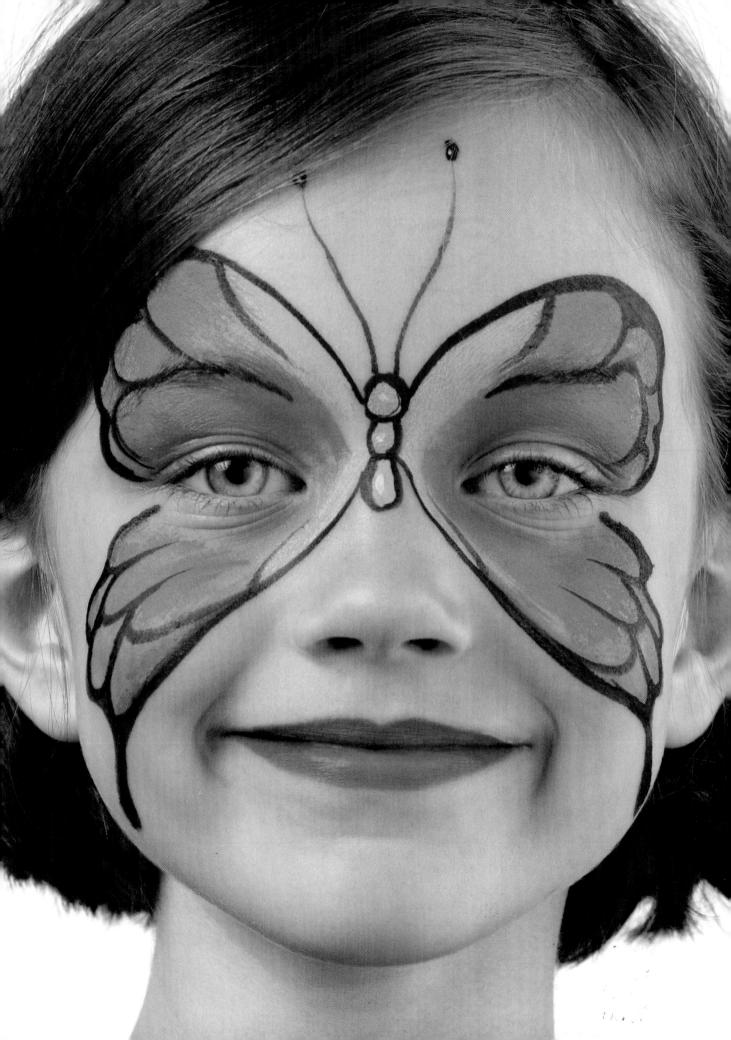

Butterfly

1 Lay in the yellow center of the butterfly's wings with a sponge, placing angled lines around the inside corners of the eyes.

2 Also with a sponge, apply orange next to the yellow centers, painting over the eyelids.

3 Still using a sponge, add neon pink farther out on the wings and over the eyes.

4 Dab on blue to the outer edges of the wings using a sponge. Allow the blue to lightly mix with the pink where the two colors meet to create a hint of purple.

Add the green body between the wings using a no. 3 round. Make sure the body is small so that it draws attention to the eyes and not the nose.

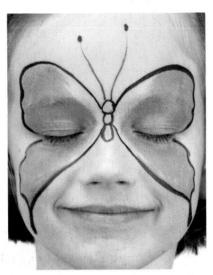

5 With a no. 3 round, outline the butterfly wings in black. Add teardrop shapes at the bottom of the wings and slightly scallop the outer edges. Outline the body as well, dividing it into three segments.

Paint the antennae, working from the head of the butterfly up; lightly flick your brush up off the face as you reach the tips. Use a no. 3 round to add small black dots to the tips of the antennae and fill in any missing color holes.

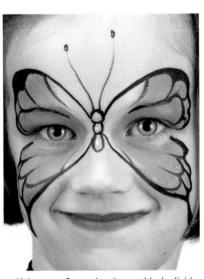

6 Using a no. 3 round and some black, divide the wings into sections, scalloping between the pink and blue. Add some more black sectioned areas to the wings and reshape the outline if needed. Also use a no. 3 round to add tiny white highlights to the antennae and body.

Fill in the lips with purple using a cotton swab.

yellow sponse nonge #3 homel Neon pink blue graen black

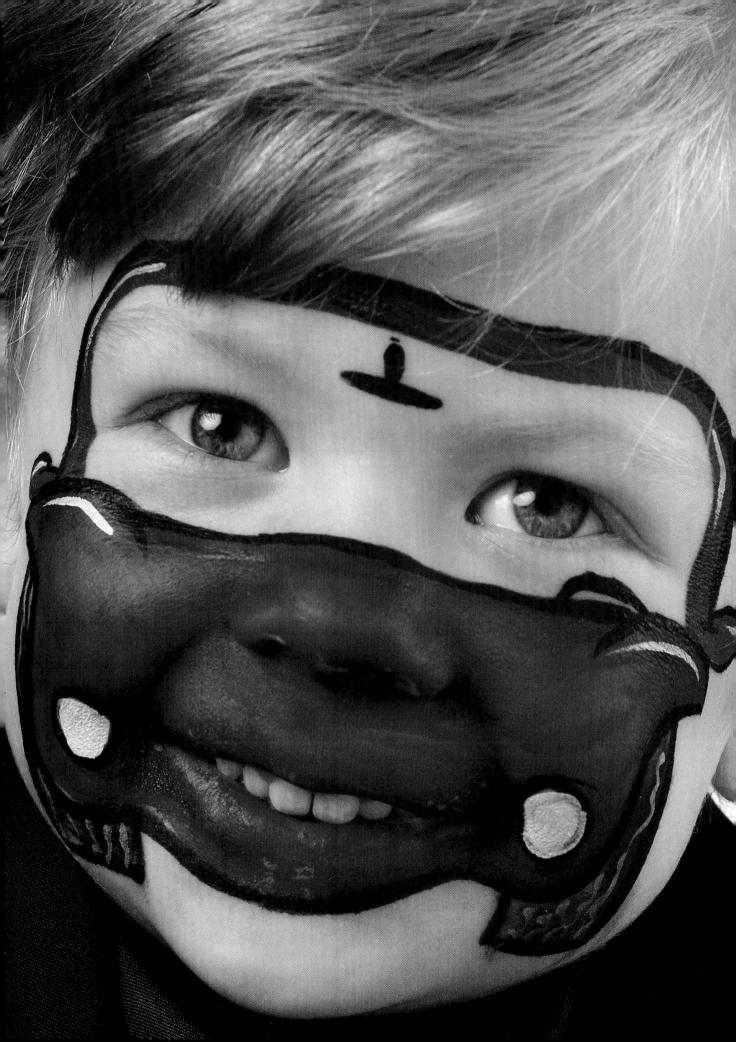

Car

1 Using a no. 3 round and red, outline the windshield and fenders of the car. Place the fenders on the cheeks so when your model smiles the car smiles, too!

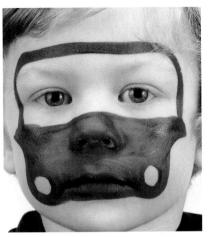

With the same brush and color, outline the headlight circles on the lower cheeks and paint in the hood of the car.

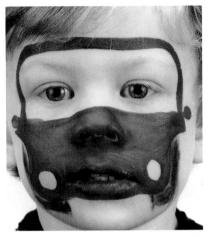

Add side-view mirrors using a no. 3 round and red. Apply the basecoat for the tires using your sponge and black.

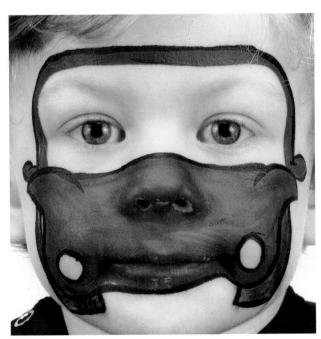

Load a no. 3 round with black and outline the outside of the car and the tires, as well as the insides of the headlights.

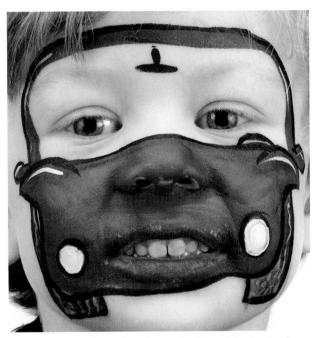

Add the T-shaped rear-view mirror and a little arch for the steering wheel using a no. 3 round and black.

Load your brush with white to fill in the headlights, add thin squiggly lines to the tire treads, and place highlights on the fender.

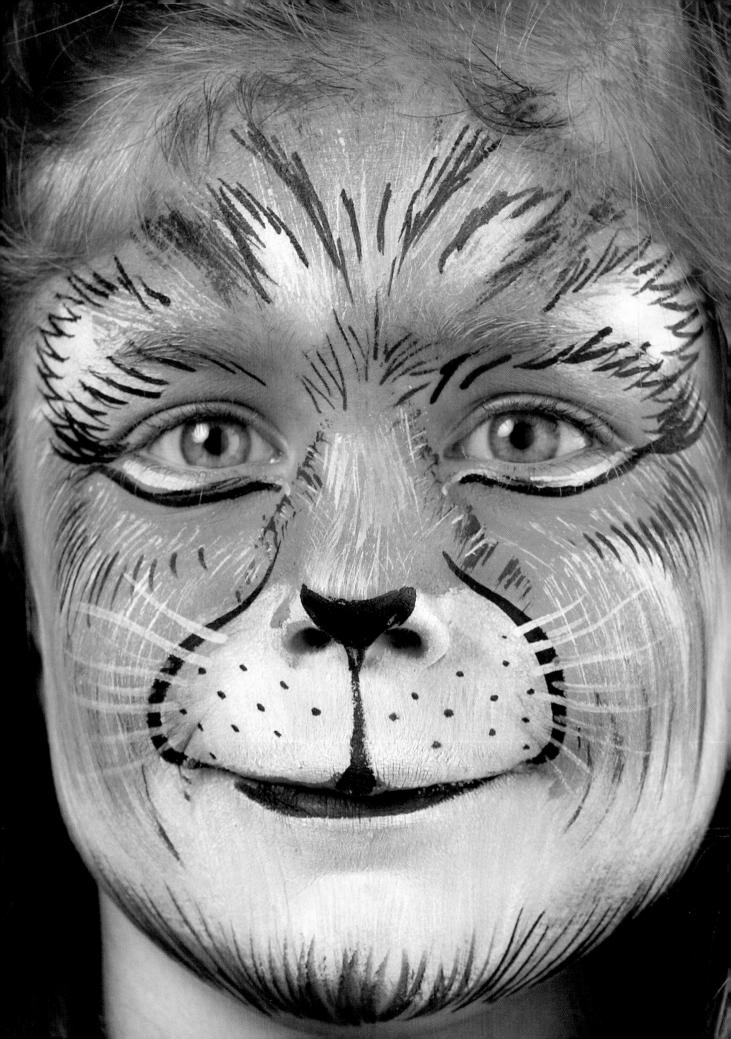

Cat

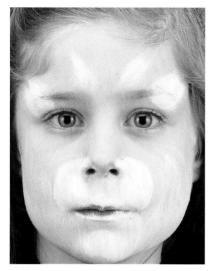

Using a sponge, apply a white basecoat to the muzzle, cheeks, eyes and ears.

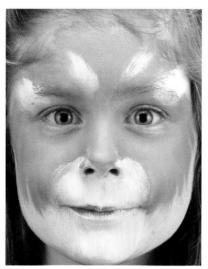

2 Fill in the rest of the face using a sponge and some gray. Apply the paint in fur-like strokes, radiating downward beneath the eyes and upward above the eyes.

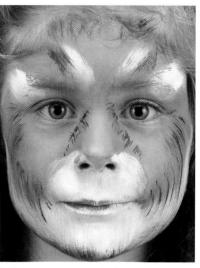

Use a sponge to stroke in some brown accents radiating from the eyes and up from the chin and jaw.

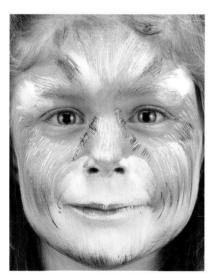

Lightly stroke white fur on top of the gray areas. Keep your sponge strokes consistent with the strokes in previous steps.

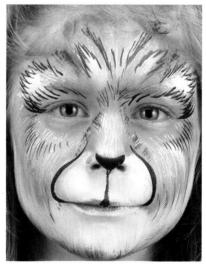

Using a no. 3 round and black, add thin lines around the brow, further suggesting the texture of fur. Add eyelashes, line the muzzle and paint the tip of the nose.

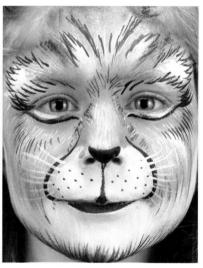

Still using a no. 3 round and black, place an outline beneath the eyes, paint the lips and add whisker spots.

Switching to white, place a thin line directly under the eyes to contrast with the black, and add the whiskers.

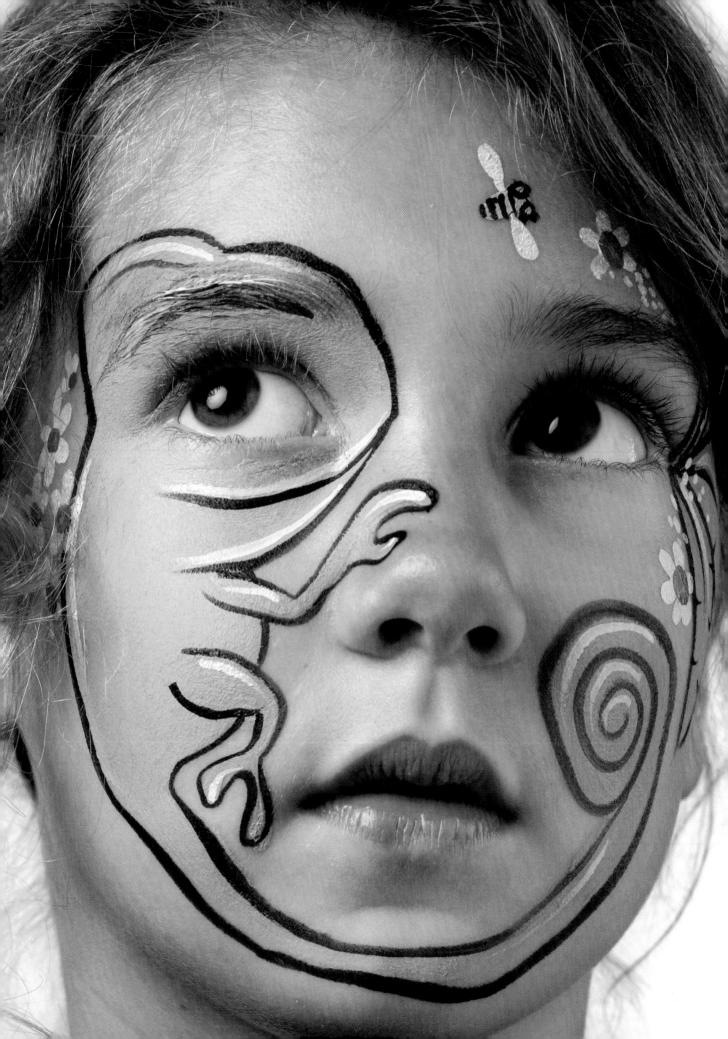

Chameleon

1 Using a sponge and light green, lay in the chameleon. Start with the head around the right eye, move down the cheek with the body, under the mouth and up the other side of the face with the tail.

Add the leaf design around the other eye with the same color. Stipple with the sponge for an opaque coat of paint. Clean up edges as needed and wipe out color with a tissue to reshape. Then, using a sponge, stroke and stipple on darker green to shadow select areas of the chameleon's body and the leaves.

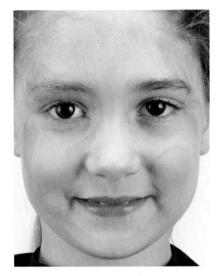

2 Add the leg and feet shapes using your no. 3 round and light green.

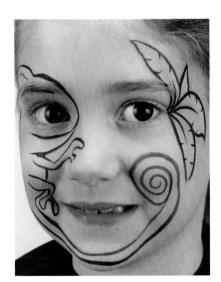

3 Outline the chameleon and leaf shapes in black using a no. 3 round. Add details to the leaves and the crest on the chameleon's head with the same brush and color.

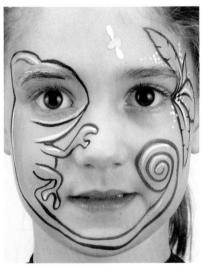

4 With a no. 3 round, add white highlights to the chameleon's body by placing thin lines directly against the black outlines. Paint a white basecoat for the bee on the forehead and the flowers that surround the leaves. Add a drop of yellow on the bee's body using the tip of your brush.

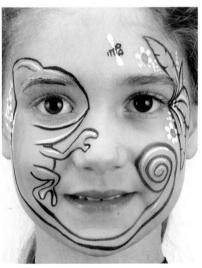

5 Using a no. 3 round, add a thin black outline around the bee's eyes and indicate the stripes on its body. Add small teardrop shapes of white to the flowers surrounding the leaves and the chameleon. Then, add pink centers to the flowers with the tip of your brush, wiggling it in a circular motion.

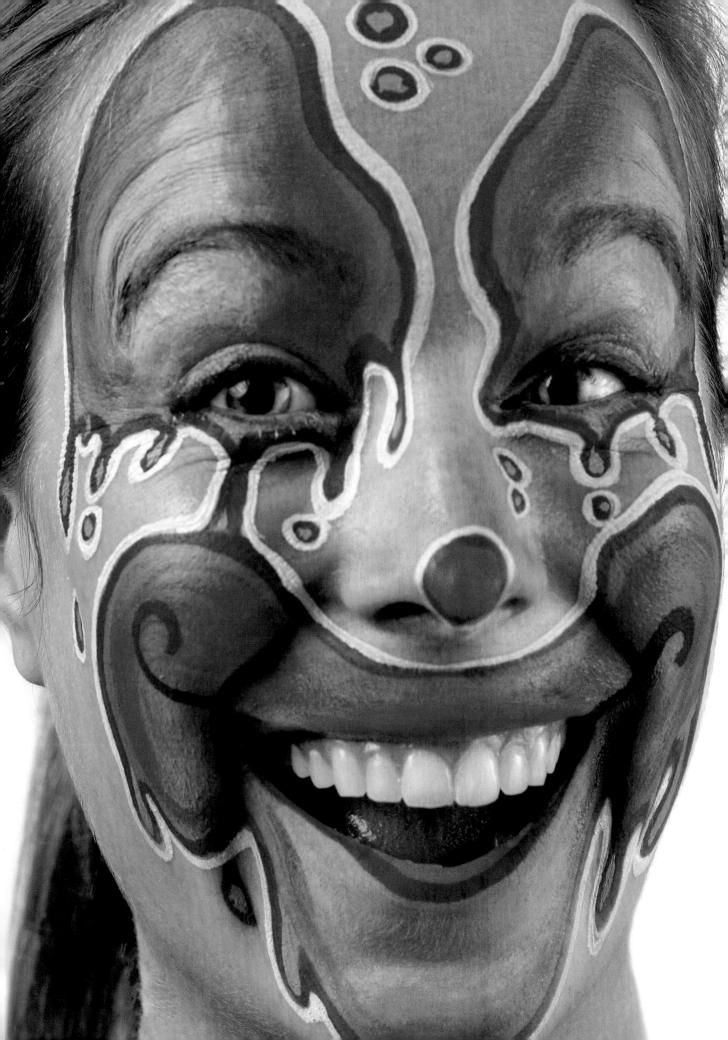

Clown

1 Preload your cake with strips of neon color, then drag your sponge once across the cake, loading it with a rainbow of colors.

Add a rainbow to the eyes, slightly squeezing your sponge as you stroke on the paint. Fill in the arch of the rainbow using the corner of your sponge and a dab of green.

2 Swipe the same sponge loaded with a rainbow of neon colors over the mouth area, moving from left to right in one big swoop.

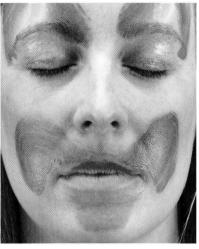

3 Reverse the rainbow on the eyelids and under the mouth, creating a reflection of sorts. Use a cotton swab to clean up areas under the eyes or to clean up edges as needed.

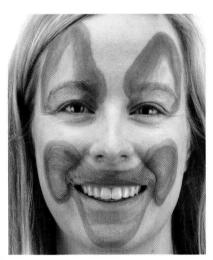

4 Outline the eye and mouth rainbows in purple using a no. 3 round. When you outline, you can also clean up the soft sponge edge.

Add paint to any non-painted holes using a no. 3 round and pink. Blend and clean edges.

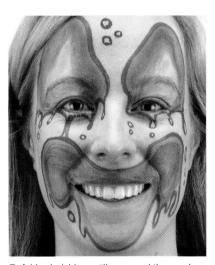

5 Add a dark blue outline around the purple outline with a no. 3 round. Suggest drips beneath the eyes and mouth, and add bubbles of water throughout with the same color.

Fill in the drips and bubbles using a no. 3 round loaded with light blue.

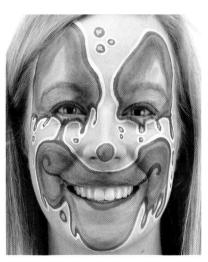

6 Outline the features in white with a no. 3 round. With the same brush, add a dark blue line to define the mouth and complete the happy expression. Add a pink circle to the tip of the nose, then outline this with a thin dark blue line and a thin white line. Place dark blue eyeliner along the upper lid by the lashes; keep the eyes closed for a few minutes while this dries.

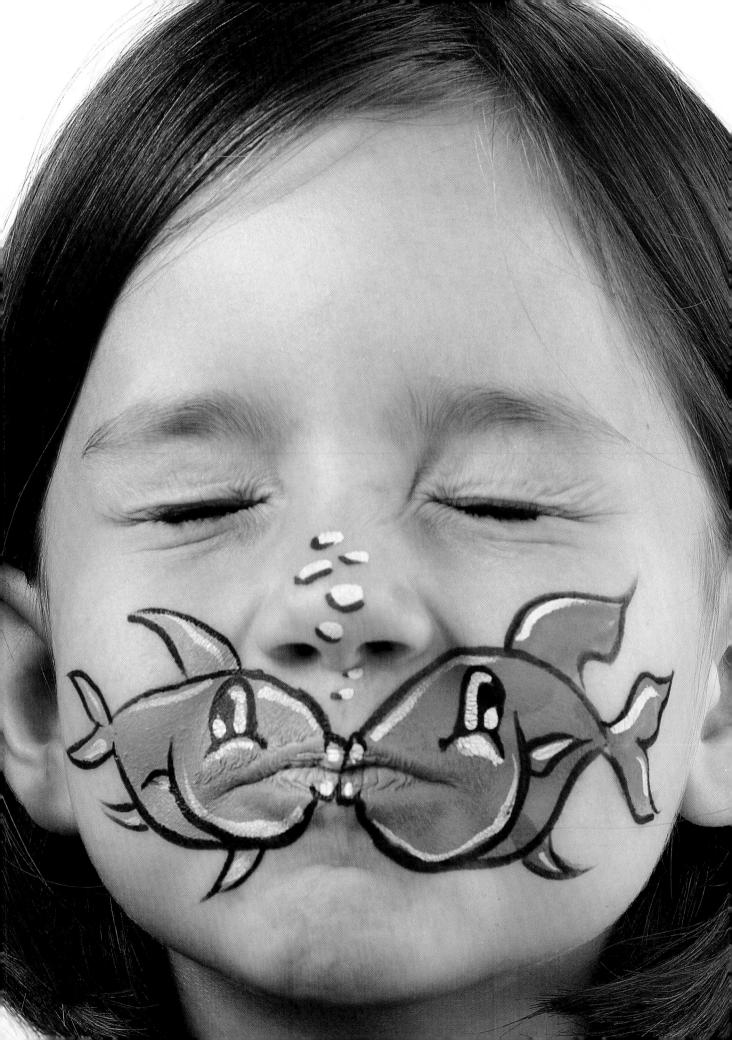

Fish Kiss

1 Apply the basecoat for the two fish using a sponge. For the fish on the left, lay in a neon pink oval, and for the fish on the right, lay in a light blue oval. Remember, the two ovals should touch in the middle to suggest they are kissing.

2 Using a no. 3 round and neon pink, add the fins and tail to the fish on the left. With the same brush and light blue, add the fins and tail to the fish on the right.

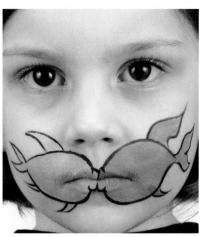

3 Outline both fish in black—including their fins and tails—using a no. 3 round.

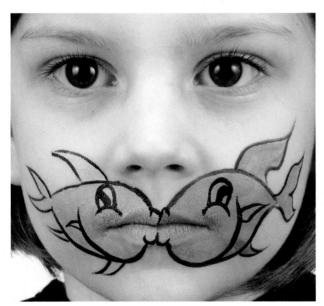

4 Add the eyes, gill slits and pectoral fins using the same brush and color.

spong #3

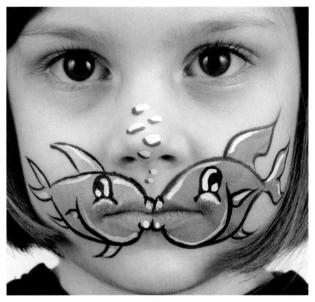

5 With a no. 3 round and some white, color in the eyes and add highlights to the bodies, fins, tails and lips. Add a few white bubbles, then place thin black lines beneath each bubble to give it dimension.

Flower

1 Apply the center of the flower using a sponge and some pink. Also add a few pink dots on the forehead and chin. Then, apply dabs of yellow around the pink to suggest the petals.

2 Paint green leaf shapes using a sponge. Then, place light green highlights on the leaves using the edge of the sponge.

3 Outline the large flower in white using a no. 3 round. Also add white lines on the petals, starting from the outside edge and moving toward the center.

4 Using a no. 3 round, add a white stamen to the large flower; place a star on the top. Add the red center, making it darkest in the middle and radiating to the tips of the petals. Add red dots to the tips of the stamen and deepen the base of the small buds with red.

Outline and highlight the leaves with white, and outline the small buds.

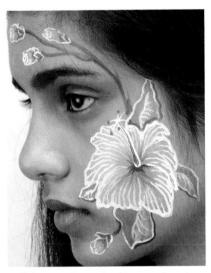

5 Using a no. 3 round, add green stems to the little buds, connecting the flowers.

Mix black with dark green and shadow the underside of the leaves and stems with a no. 3 round.

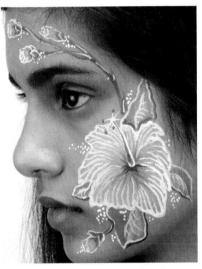

6 Place little white dots around the large flower to indicate baby's breath using the tip of your round brush. Also add white highlights to the stems.

pink green green hight green white nea gark green sponge #3

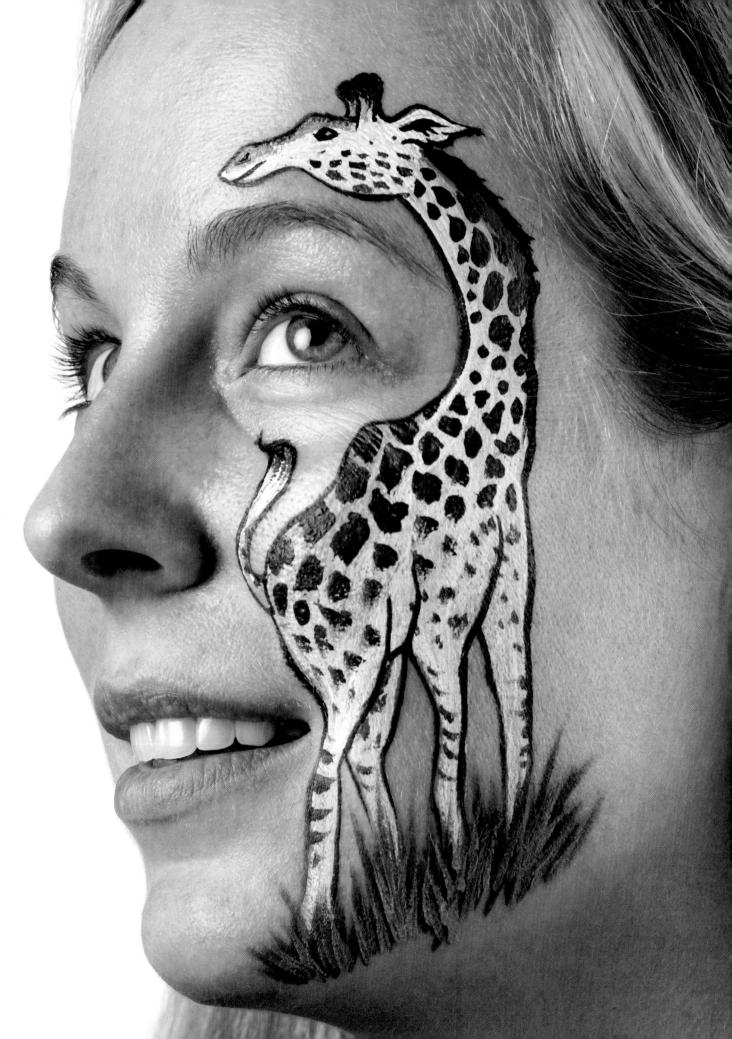

Giraffe

1 Using reference pictures as your guide, paint the giraffe's basic shape with a no. 6 round and white. Place tan shading along the neck and back to add dimension using the same brush

2 Add grass with a no. 3 round and dark green, making it thickest at the bottom and thinnest at the tips of the blades. Using the same brush, add strokes of lighter green to give the grass texture.

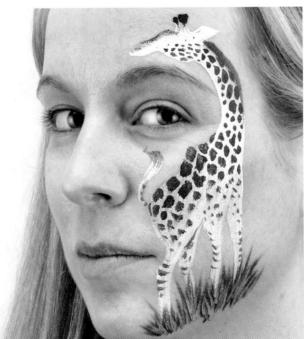

3 Add brown reticulated spots on the body with a no. 3 round. Place larger spots at the top of the back and on the outside of the neck, and smaller spots on the face, on the inside of the neck, and toward the chest and belly. Add the striping on the legs and color the tips of the horns. Then add a strip of brown along the outside of the neck to indicate the mane.

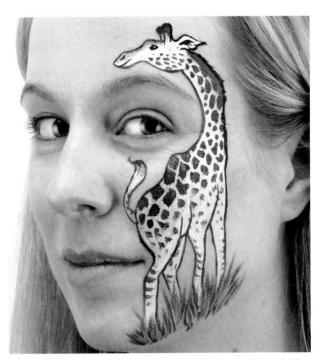

4 Add the eye and mouth using a no. 3 round and some black. Add details to the ears and tail, and outline the body using the same brush and color.

while

tan

dark gruen

light green

brown

brown

#43

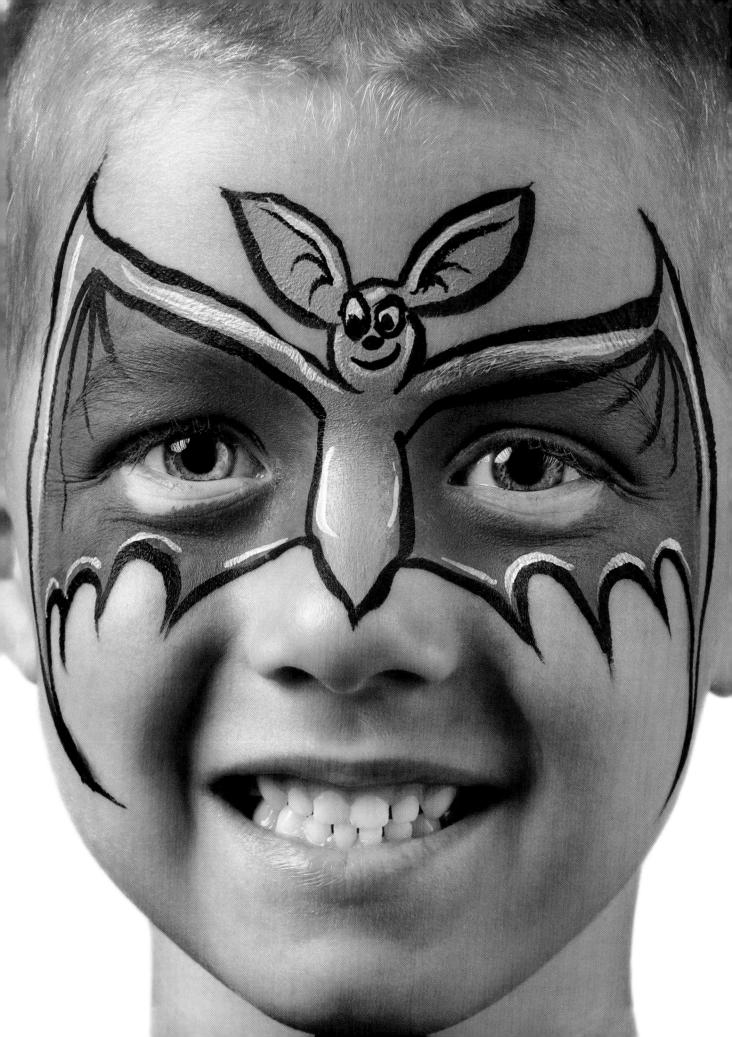

Happy Bat

1 Load the end of the sponge with light blue and lay in the bat's head and body across the bridge of the nose. Then, create the outline of wings above the brows and down the temples using the same color.

2 Fill in the wings around the eyes using a sponge and dark blue. Drag the paint down into points on the cheeks using the corner edge of the sponge.

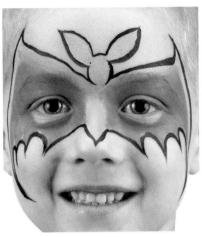

3 Outline the bat's wings, body and head with thick black lines using a no. 3 round.

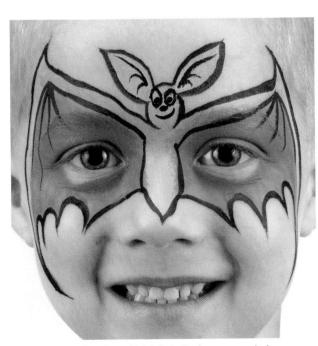

4 Use the same brush to add details to the face, ears and wings.

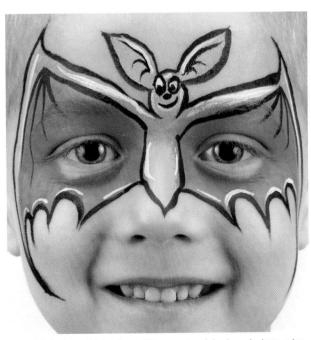

5 Highlight the outside edges of the ears, head, body and wings using a no. 3 round and white. Fill in the eyes using the same brush and color.

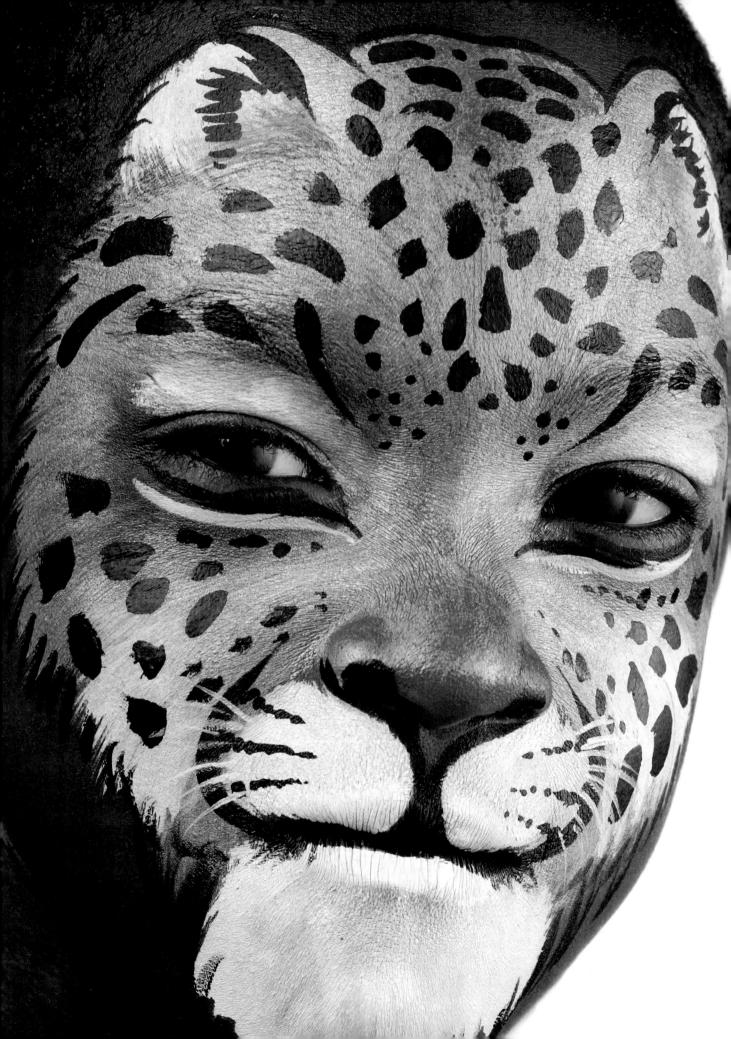

Jaguar

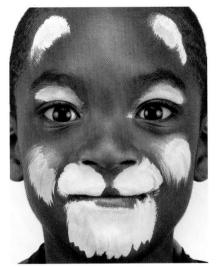

1 With a sponge, apply white to the lighter fur areas around the mouth, cheeks, eyes and ears (the two spots on the forehead).

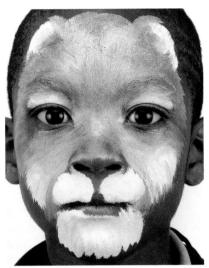

2 Sponge gold onto the remaining areas of the face to create a basecoat for the fur. Stipple on brown to shade the nose, eyes, ears and top of the head.

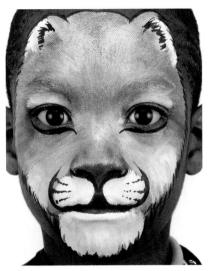

3 Outline the face with short strokes of black using a no. 3 round. Add this same texture to the inside of the ears.

With the same brush and color, outline the muzzle area and place black lines beneath the eyes. Add small dots to indicate the whiskers.

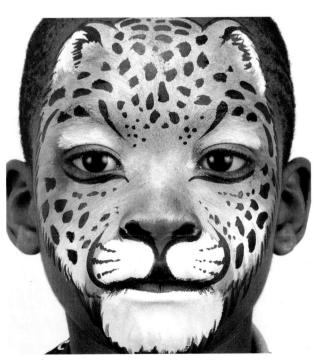

4 Using a no. 3 round, add black spots on the face, beginning with the small dots under the eyes. Then, working your way down from the top of the head, add spots to the rest of the face, placing the smallest dots closest to the eyes and nose.

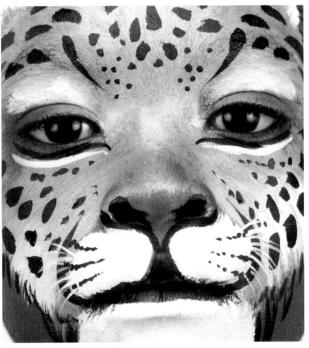

5 Using a no. 3 round, add a white line under the black eyeliner on the lower lid. Finally, add thin white whiskers using the same brush.

gold sponge white #3 would black

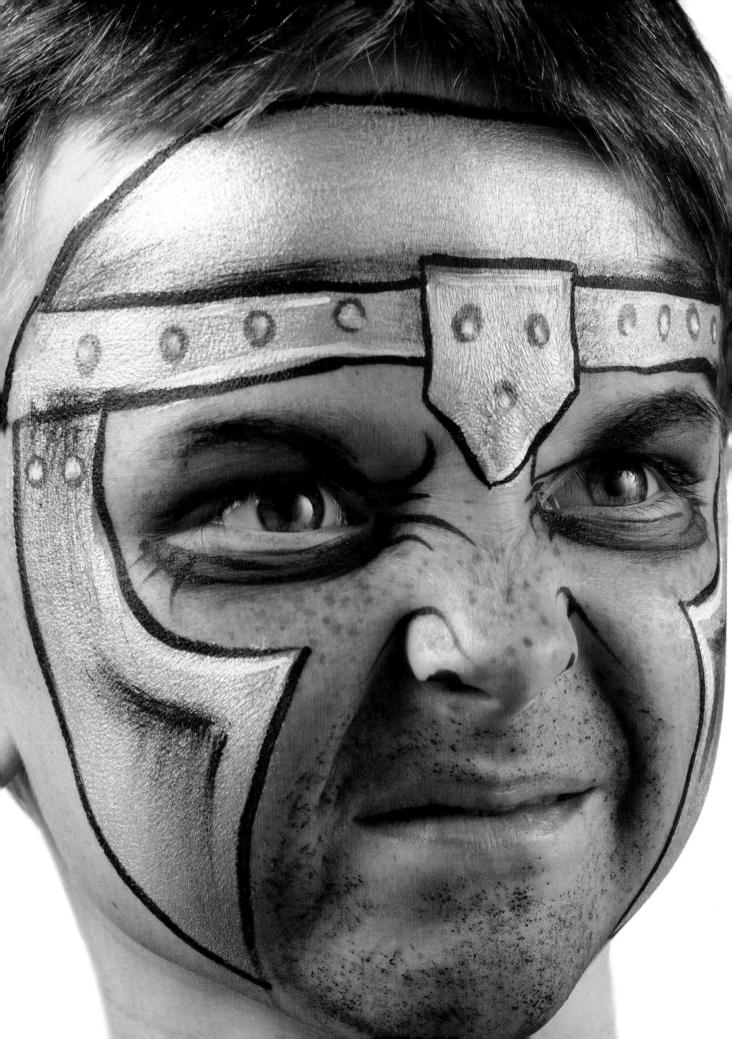

Knight

1 Using a sponge, lay in dark brown above and below the eyes and tan over the eyelids, making the eyes appear sunken in.

Next, load one side of a sponge with silver and lay in the basic helmet shape. Paint with smooth, long strokes, then stipple on more color to make the sheen opaque.

2 Load the end of a sponge with black and stipple lightly to suggest the texture of facial hair and stubble. Use the edge of the sponge to scrape on eyebrows.

3 Using the edge of the sponge loaded with black, drag down paint to shape and add dimension to the helmet. Add the bridge guard between the eyes using a sponge and silver.

4 Using a cotton swab loaded with black, indicate the rivets on the helmet. Apply the swab directly on the skin and spin it to get a perfect circle. Then, load white onto the cotton swab and add small circular highlights to the rivets.

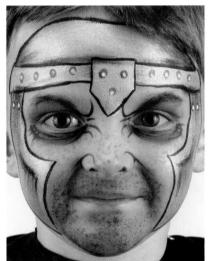

5 Outline the helmet with black using a no. 3 round.

Add crow's feet and snarly wrinkles around the eyes and on the nose using the same brush and dark brown.

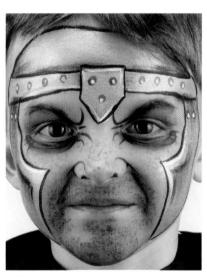

6 To make the helmet appear as though it is coming off of the face, add white highlights along the edges using a no. 3 round. Add thin white lines directly against the black outline to suggest dimension.

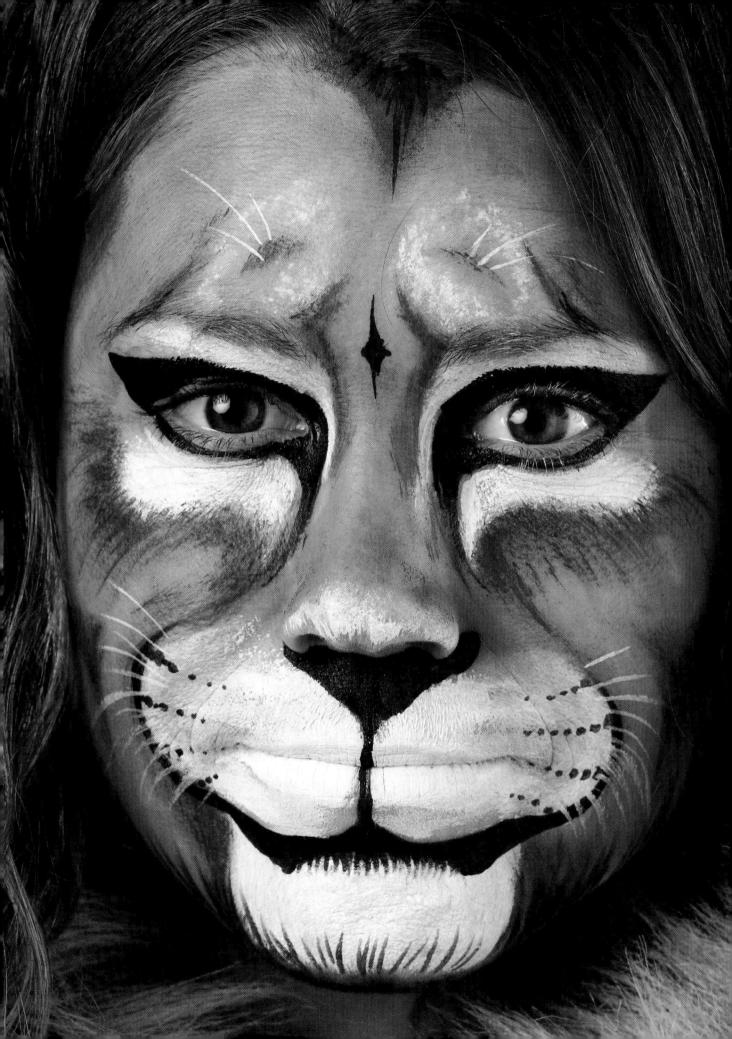

Lion

1 Apply a white basecoat to the muzzle and eye spots, shaping the areas with the edge and corner of the sponge.

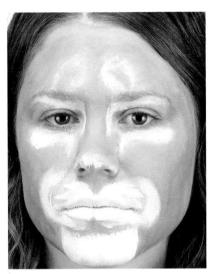

2 Apply tan on the entire face around the white areas using a sponge. Stipple over the forehead spots to blend.

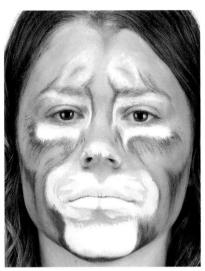

3 With a sponge and dark brown, shade around the white shapes and add a widow's peak. Following the contours of the face, use the sponge to suggest fur texture as you shade beneath the eyes and on the cheeks and chin.

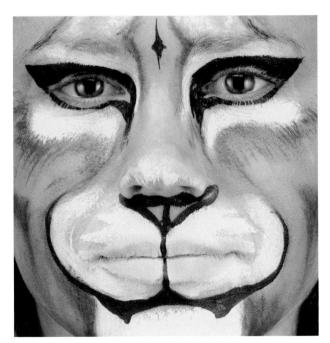

4 Use a no. 3 round and black to outline beneath the eyes, paint the eyelids, add the dark spot to the bridge of the nose, divide the muzzle and outline and shape the muzzle. Paint the lion's nose under the model's actual nose using the same brush and color.

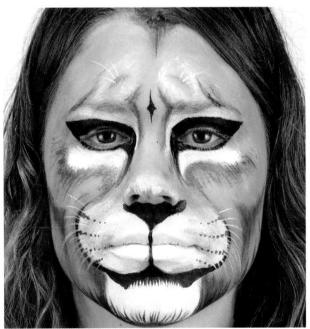

5 Fill in the nose and add fur texture to the top of the chin beneath the lip using a no. 3 round and dark brown. With the same brush and color, dot in whisker spots and add more fur texture around the bottom of the chin and jawline. Finally, add white whiskers along the brow and muzzle with a no. 3 round.

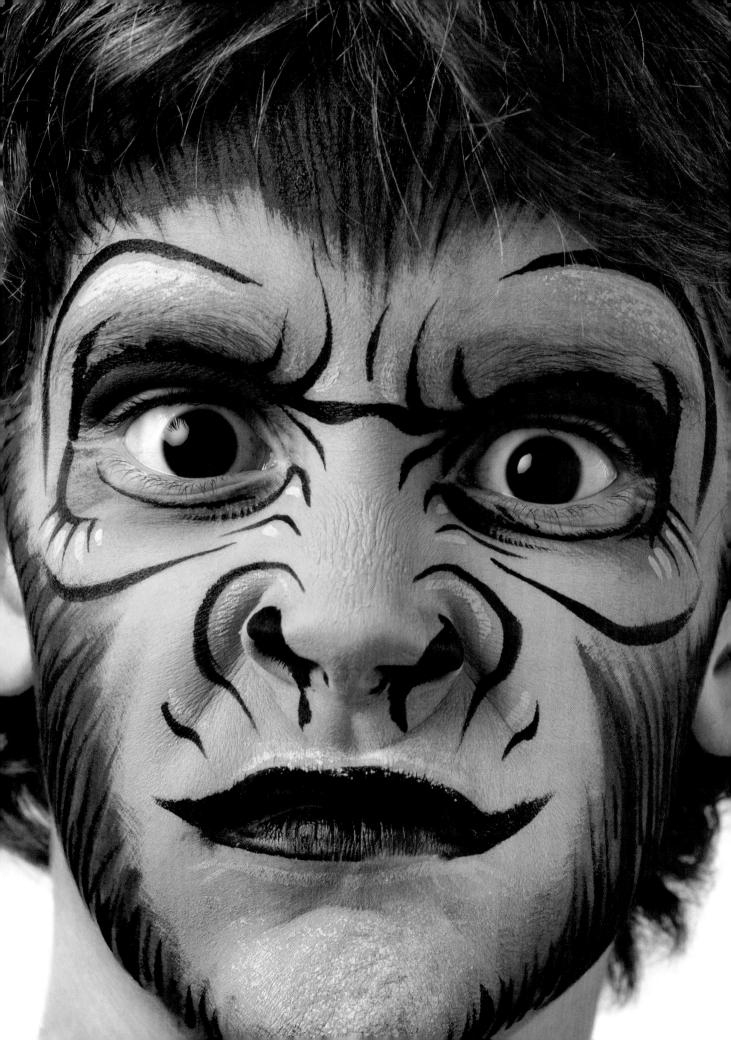

Monkey

1 Sponge a flesh tone on the entire face, first applying strokes and then stippling to fill in and make the basecoat opaque.

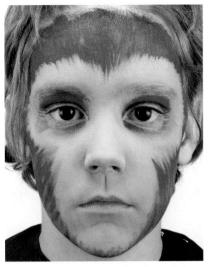

2 Drag hair strokes from the edges of the face inward using a sponge and brown. Apply the same color to sink in the eyes.

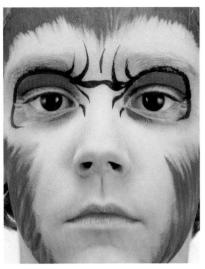

3 Place a black outline above the eyelid (directly beneath the brow) using a no. 3 round. Add wrinkles in the corners of the eyes and over the bridge of the nose using the same brush and color.

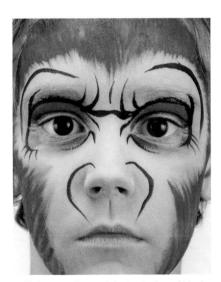

4 Using a no. 3 round, lay in strokes of black to suggest the eyebrows. Outline the nostrils and develop the eyes with additional linework using the same brush and color.

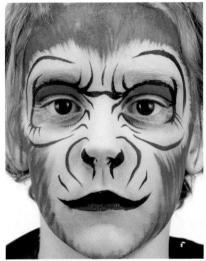

5 Using a no. 3 round and black, continue developing the face, adding more wrinkles to the mouth and nose, and filling in the nostrils and lips.

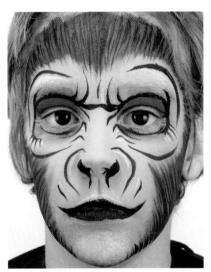

6 With the same brush, add black strokes on top of the hair, moving from the outside edges to the center. Overlap strokes. Add a thin black line along the bottom of the eyes.

Use a no. 3 round to add off-white highlights along the wrinkles. Use a sponge to stipple highlights on the brow and chin.

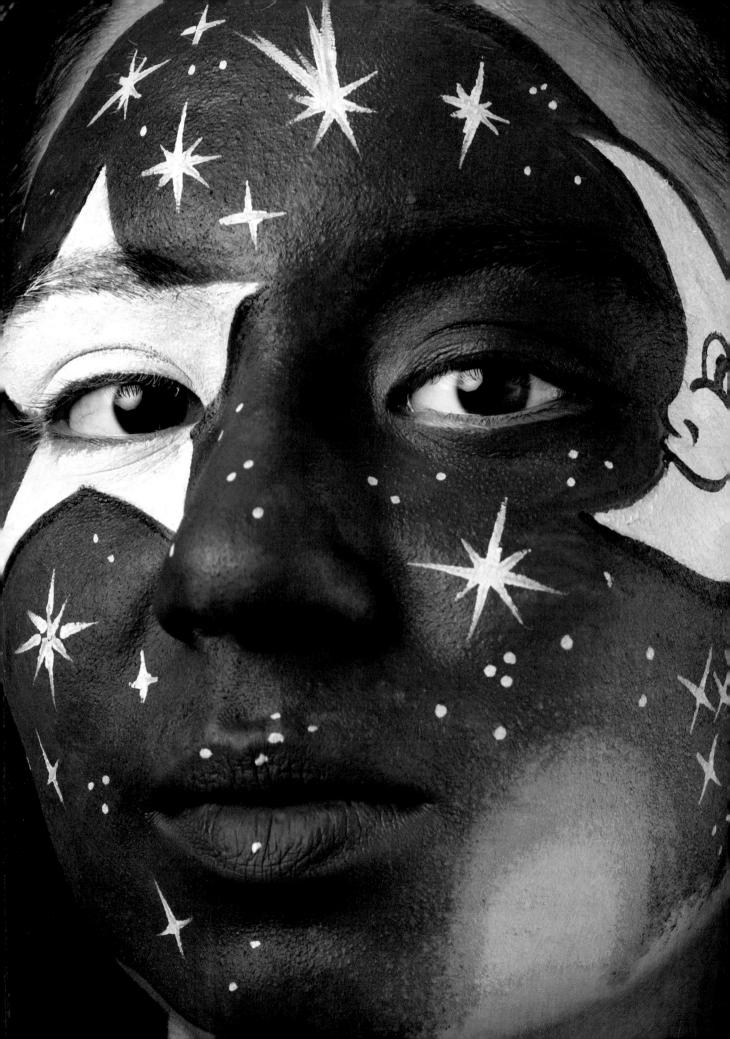

Night Sky

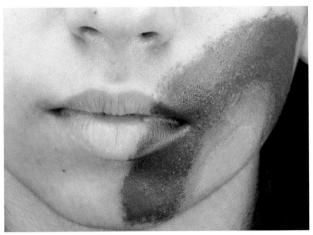

1 Using sponges, paint a sunset at the bottom of the left jawline, beginning with the yellow center. Add a strip of neon pink around this center, stippling into the yellow. Then, add a wide strip of purple to create the outside edge of the sunset.

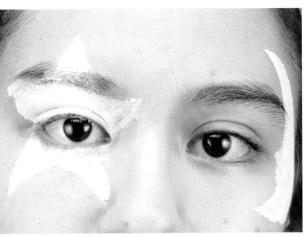

2 Use a sponge to apply a white basecoat for the moon on the left temple and the star over the right eye.

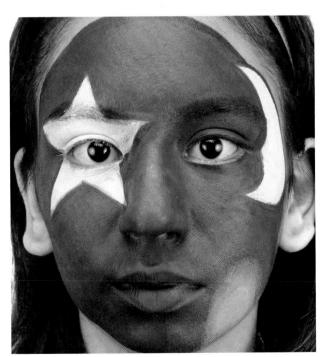

3 Lay in a dark blue sky around the sunset, moon and star using a sponge. Then using a no. 3 round and the same color, define the sharp edges around the star and moon.

sponge \$3

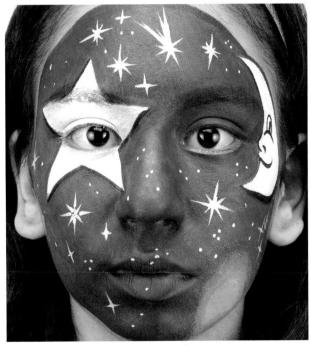

4 Use a no. 3 round and black to add a cute eye, nose and smile to the moon, and add shadows underneath the moon and star.

Use a no. 3 round and white to add star clusters in the night sky and to touch up the white on the large star. Add a shooting star on the forehead, and place small dots for tinier stars.

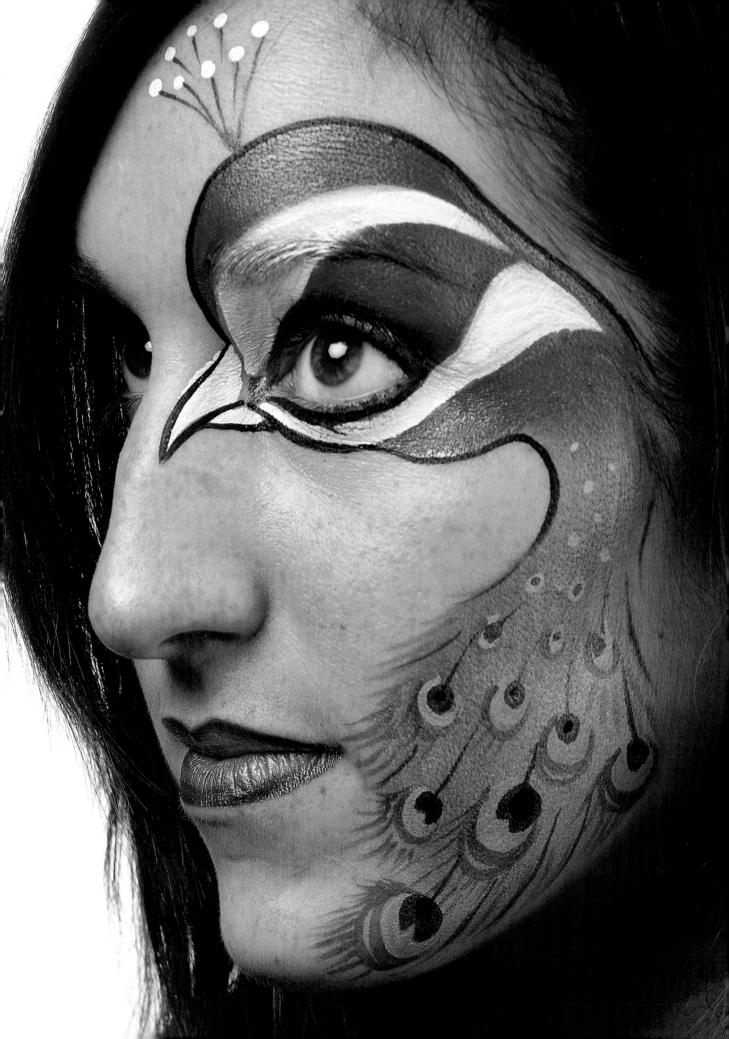

Peacock

1 With a sponge, apply a metallic blue basecoat around the left eye for the peacock's head. Apply a metallic green basecoat down the cheek to suggest the feathers, blending into the blue where the colors meet.

2 With a sponge, stipple gold directly over the green toward the bottom of the feathers.

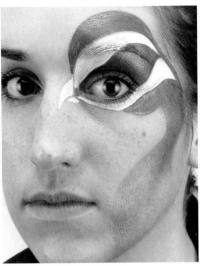

3 Add white to the negative spaces around the eye using a no. 3 round. Sharpen the edges of your sponge work using metallic blue and the same brush.

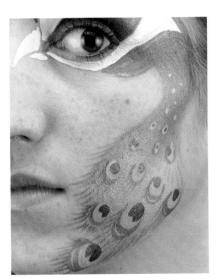

4 With your no. 3 round, add light blue to the tail feathers, enlarging and changing the dots into moon shapes as you work down the face. Use metallic purple to fill in the blue centers.

Outline the bottoms of the feather circles and add small barbs radiating from them using a no. 3 round and a brown and gold mix.

white

sound and a brown and gold

metallic purple

metallic green

white

high blue

brown

gold

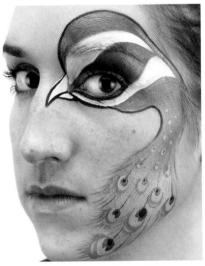

5 Using a no. 3 round, add small black spots to the center of the feather spots. Then, with the same brush and color, outline the eye, beak and head.

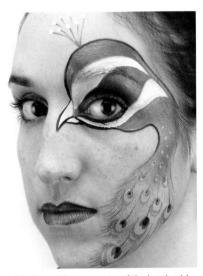

6 Starting at the top center of the head, add very faint lines of metallic purple with a no. 3 round to suggest plumes. Then, use the handle end of your brush dipped in white to apply small round dots to the tips of the plumes.

Using a cotton swab, outline the lips with metallic blue and purple; fill them in with green. Swab a faint gold sheen over the green.

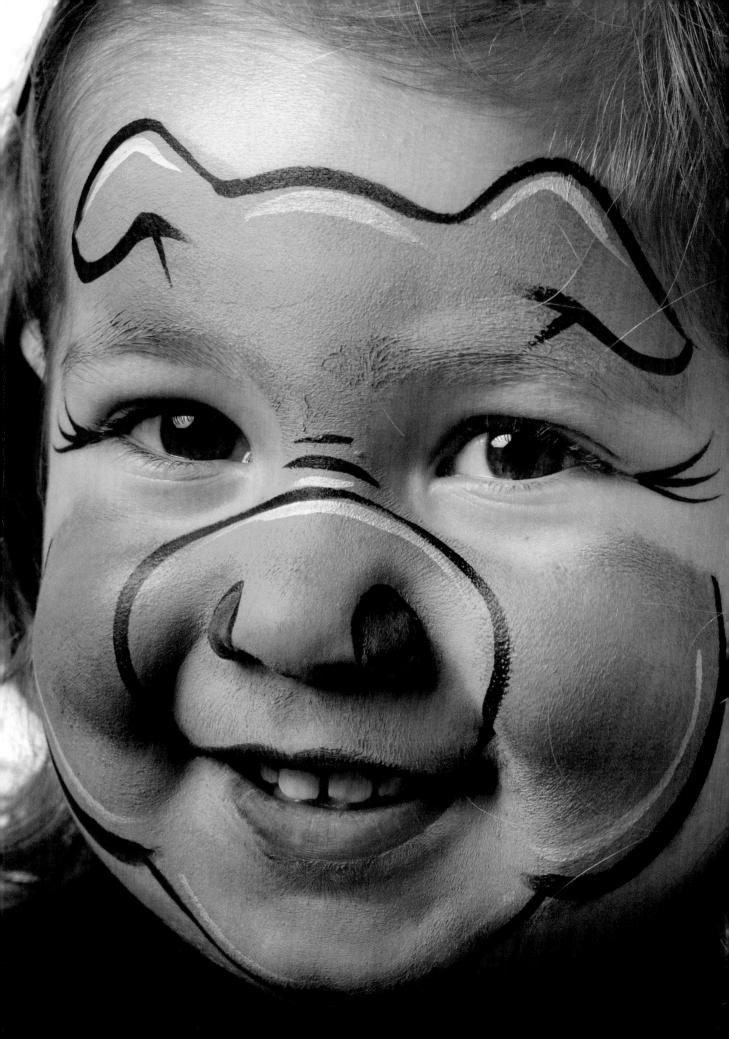

Piglet

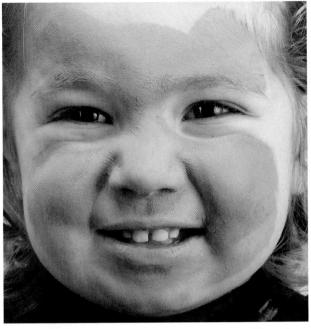

1 Apply a pink basecoat to the entire face using a sponge. Then, give the face some dimension by adding shadows under the ears and on the cheeks using a sponge and a mixture of pink and purple with a hint of red.

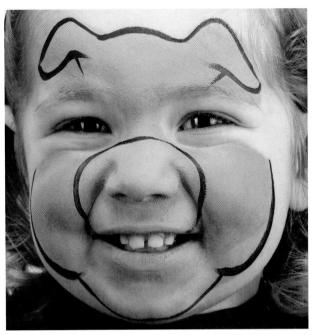

2 Using a no. 3 round, outline the ears, nose and face with thin black lines.

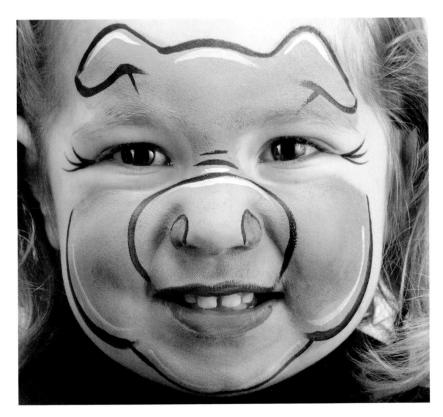

3 With the same brush and color, add the eyelashes and nose details. Fill in the nostrils and lips with some red mixed with pink. Then add white highlights on top of the head, ears, nose and cheeks, and deepen the lips with the pink-red mixture.

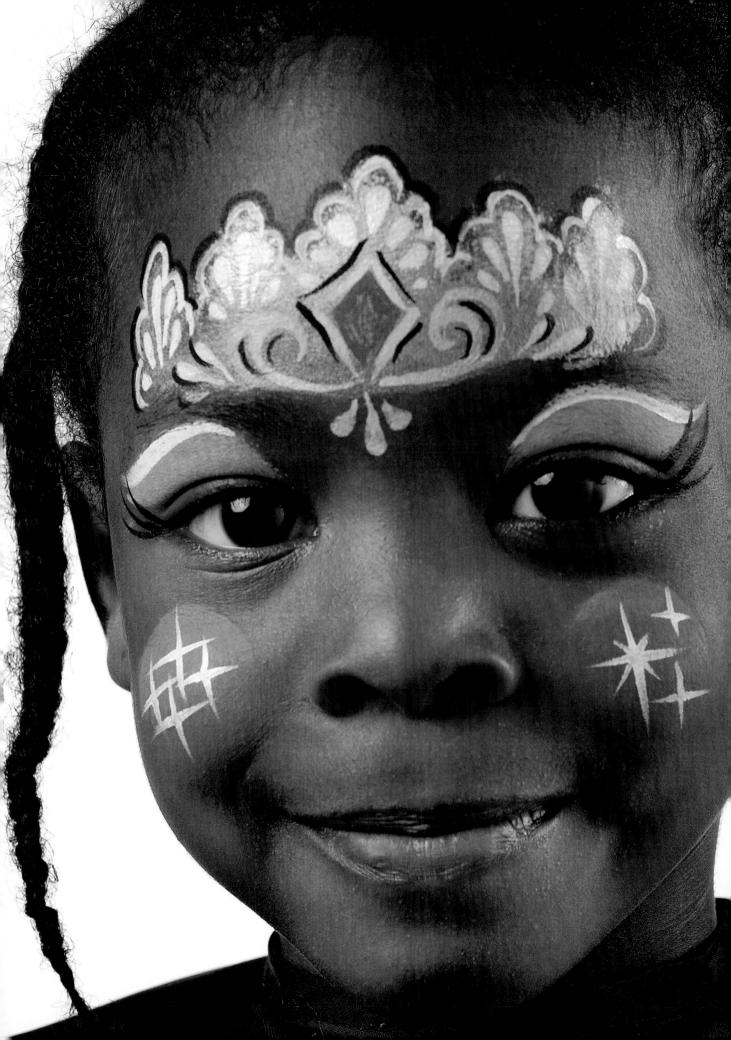

Princess

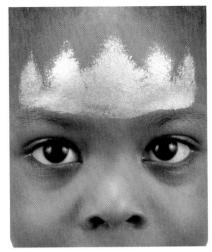

1 Apply a gold basecoat to the forehead in the shape of a crown, using the edge of your sponge to stipple on the crown points. Clean up any edges with a cotton swab.

2 Apply blue eye shadow with a sponge. Make the eyes pop with dark blue eyeliner applied with the edge of the sponge.

3 Apply pink with the end of the sponge, turning it in a circular motion to create rosy cheeks. Apply pink to the lips with a cotton swab.

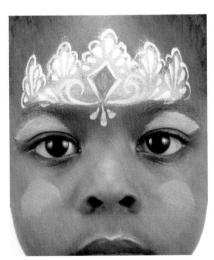

4 Add a pink diamond jewel in the middle of the crown using a no. 3 round. Use the same brush loaded with white to paint the swirls, curls and teardrops on the crown, and to scallop the tips of the points.

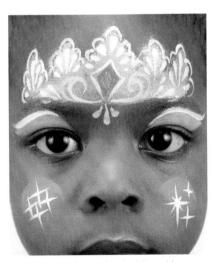

5 Using a no. 3 round and white, add some stars to the cheeks and place a highlight line above the blue eye shadow.

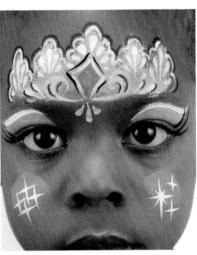

6 Outline the crown and add interior details using a no. 3 round and black. Also add eyelashes using the same brush and color.

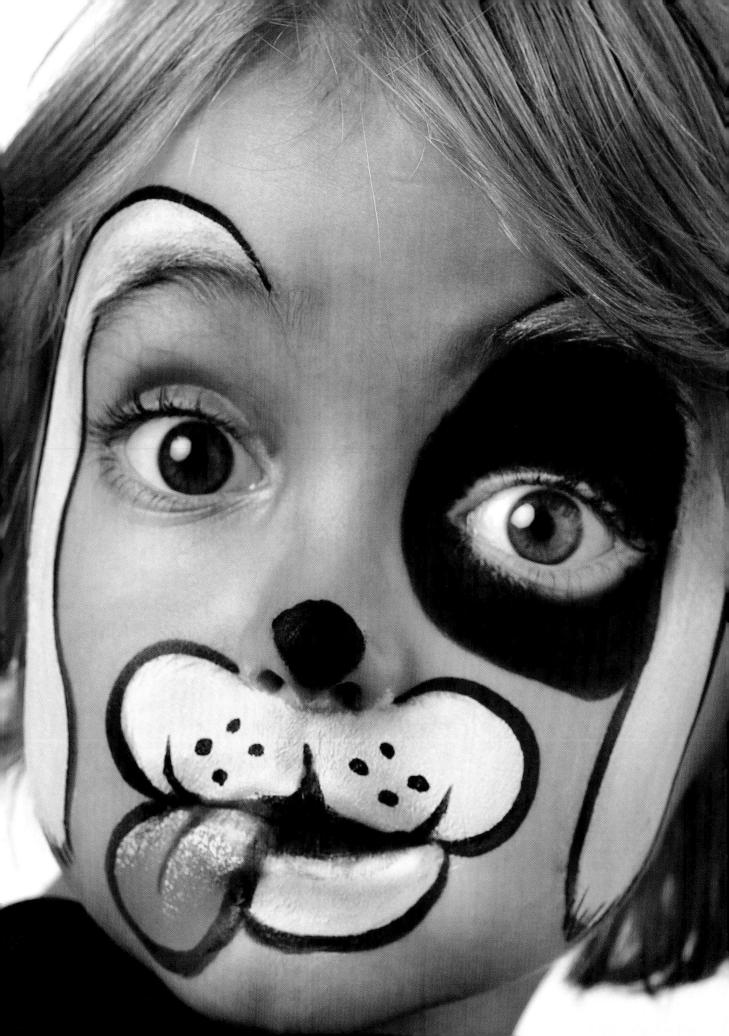

Puppy

Lay in the ears and muzzle shape using a sponge and white. Leave room for a tongue on the right side of the mouth.

2 Add a black circle around the left eye and a dab of black on the tip of the nose using a sponge.

Sponge on a pink tongue, then stipple in some white highlights. Outline the tongue using a no. 3 round and red.

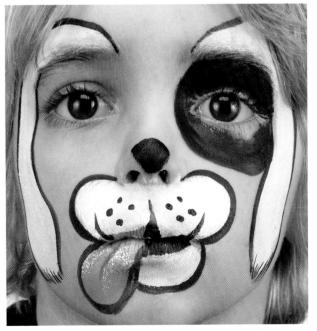

Use a no. 3 round and black to outline the ears, sharpen the edges of the eye and nose, and add whisker spots and a mouth.

Rainbow

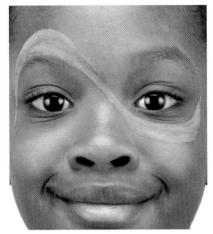

1 Using a sponge, paint the first two stripes of the rainbow figure eight shape. Begin with a blue stripe, then add a stripe of light green on either side of the blue, being careful to avoid crossing the bridge of the nose with the green paint.

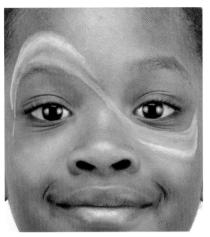

2 Add a yellow stripe on either side of the green and an orange stripe next to the yellow. Notice that because you are painting a figure eight shape, each new stroke of color is shorter than the one before.

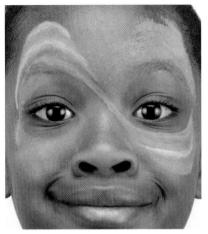

3 Add a thin pink stripe next to the orange and a thin stripe of purple next to the pink. Then, use a sponge to stipple in purple cloud shapes above the left eye and beneath the right eye, completing the figure eight shape.

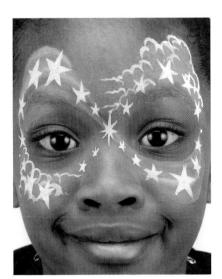

4 Using a no. 3 round and some white, suggest cloud details and add in stars on top of the rainbow. The stars should get smaller in the thinner areas of the rainbow and bigger toward the thicker sections. Make the center star extra sparkly for effect.

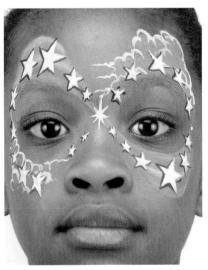

5 Carefully outline the stars in black using a no. 3 round.

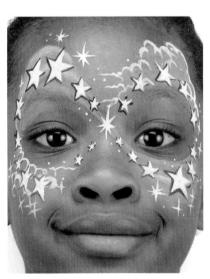

6 Add sparkles and twinkles here and there throughout the design using a no. 3 round and white. Use a cotton swab to add pink lip color.

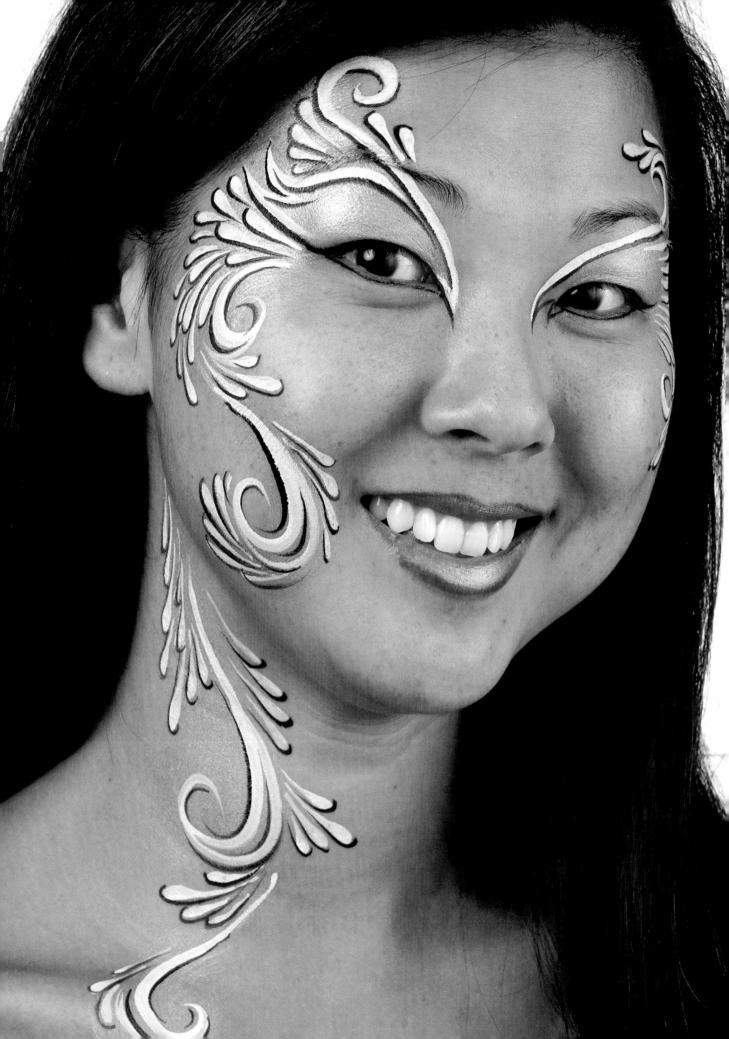

Swirl Design

1 Apply a gold basecoat over the eyes using a sponge. Blend the color outward with the dry side. Also add color to the right cheek and down the right side of the neck, moving your sponge in a swirl motion.

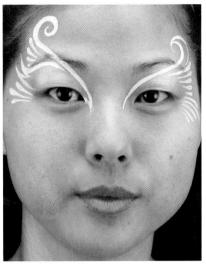

2 Stroke on white decorative lines using a no. 3 round. Begin by adding swirls at the top of the eyes, outlining the edges of the gold. Place teardrop shapes to the sides of the eyes, applying the paint directly over the gold basecoat.

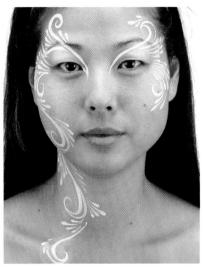

3 Continue developing the decorative linework down the face and neck, applying the white directly over the gold basecoat. Add more linework over the evebrows and along the sides of the eyes.

4 Add black shadows to the underside of the white swirls and decorative shapes using a no. 3 round. Then, line the top lid of each eye with a thin line of black using the same brush.

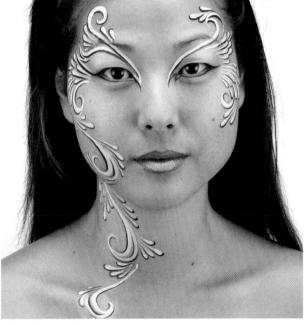

5 Continue shadowing, adding black lines to the swirls on the neck. Apply black eyeliner under the eyes.

Paint the lips metallic rose using a cotton swab, then cover this color with a layer of gold to tie the lips to the design.

gold spong white £3 black metallic rose

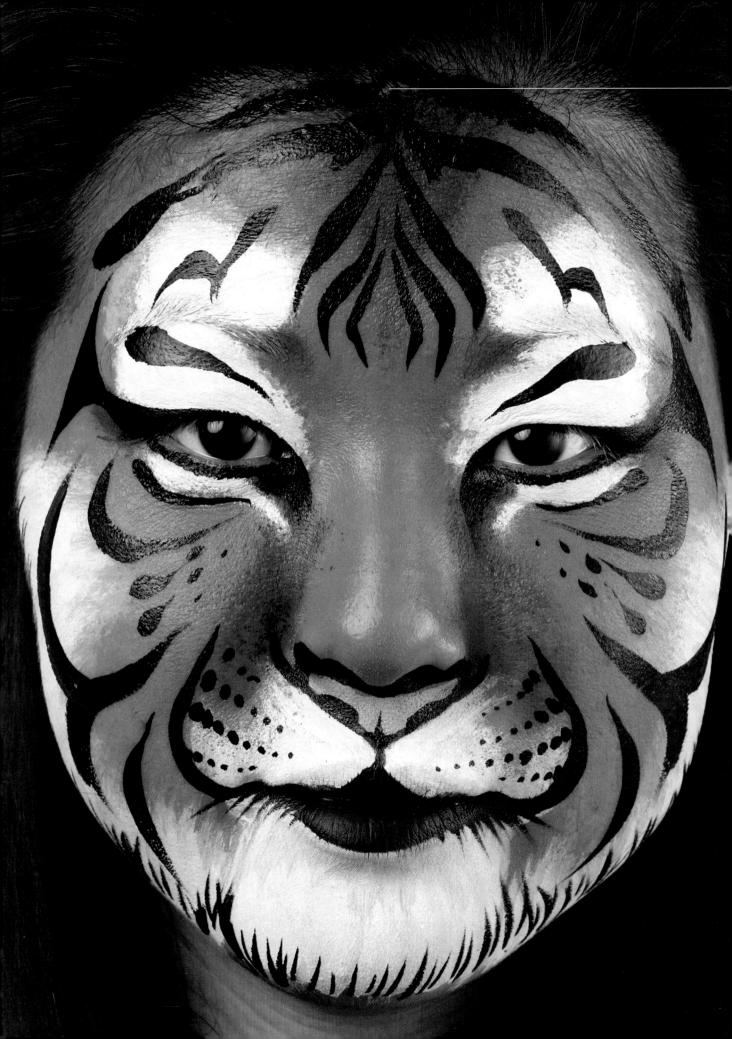

Tiger

1 With a sponge, lay in white eye spots, painting directly over the eyelids. Add the white of the muzzle, painting around where the nostrils will be. Add white to the cheek and chin, applying the paint in strokes that move from the center of the face out toward the ears. Place thin white spots under the eyes.

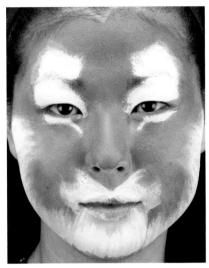

2 Add the orange basecoat of fur, then stipple it into the white to blend.

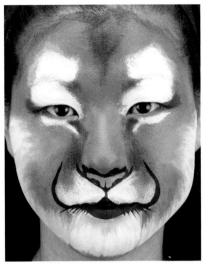

3 Using a sponge, apply brown in the corners of the eyes and along the sides of the nose. Paint a widow's peak on the forehead and add brown to the lash line, exaggerating the eyes. Use the edge of the sponge to blend.

Color the underside of the nose with orange, then switch to a no. 3 round for pastel pink. With a no. 6 round and black, define the lips and muzzle.

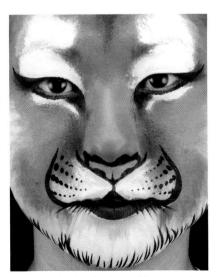

4 Further develop the shape of the eyes using a no. 3 round and black. Add black dots curving down along the lines of the mouth, placing smaller dots closer to the center. Suggest fur at the base of the muzzle and jawline, stroking your brush upward from the bottom.

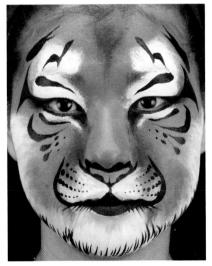

5 Using a no. 6 round and black, add the stripes. Start at the corner of the eyes, and use teardrop shapes that face away from the eyes and make curves that go from thick to thin. While stylizing the stripes, be sure to keep them symmetrical.

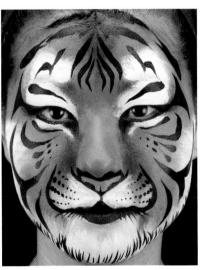

6 With the same brush and color, add stripes to the center of the forehead and around the face, using the shape of the face as your guide.

White prange brown black pastel piak

Spruge #3 # L

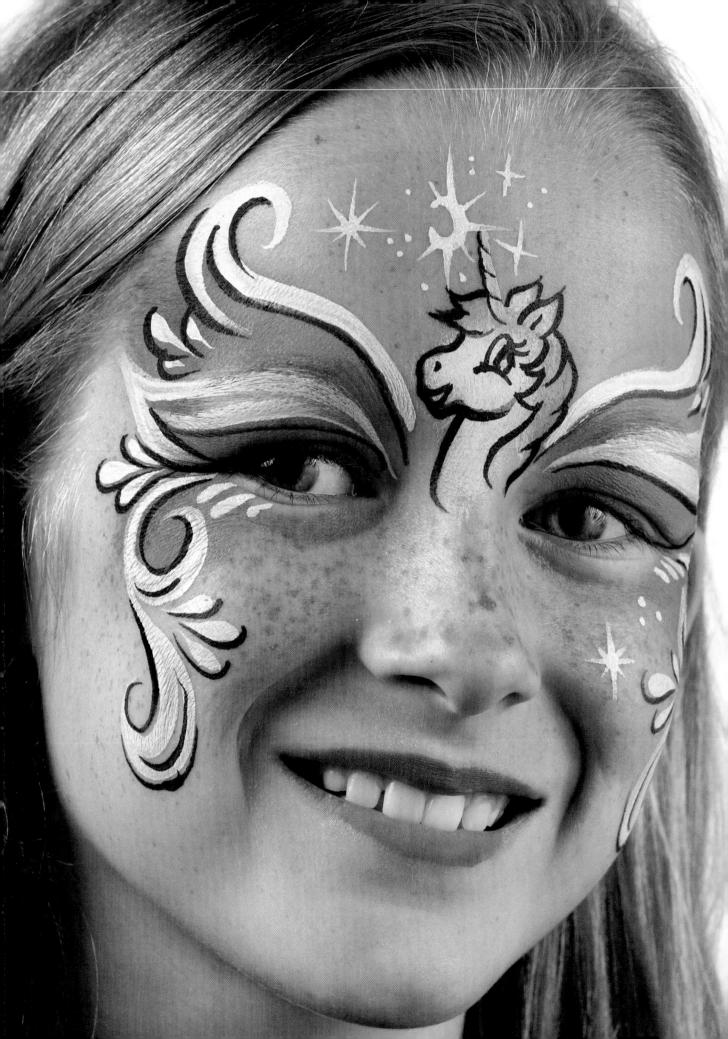

Unicorn

1 Load a sponge with white and paint a simple horse head shape between the eyebrows. Also apply strokes of white directly on the eyebrows.

Then, load the end of the sponge with pink and suggest the wings and mane, making sure to leave the white of the unicorn's ears showing through the mane.

2 Load a sponge with blue and use the edge to line the eyes along the upper lids. Dab blue on the outer edges of the wings as well, lightly blending into the pink to create hints of purple. Use the clean side of the sponge to soften and clean edges.

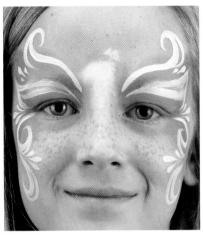

3 Add lines and flourishes that enhance the wing shape using white and your no. 3 round. Also add decorative teardrop shapes to embellish the design.

4 Using a no. 3 round and black, outline the unicorn's head, ears, neck and mane, and add a mouth, nostril and cute eye to define the face.

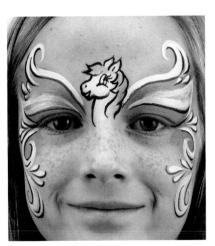

5 Shadow the outside edges of the flourishes by adding thin black lines with a no. 3 round. Make sure to shadow beneath the decorative shapes as well.

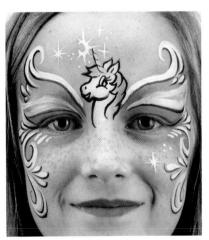

6 Add the unicorn's horn using a no. 3 round and a mixture of yellow and white. Blend the base of the horn into the mane using a cotton swab, then add small details to the horn using the brush.

5000ge

white
pink
blue
black

Mix blue and pink and apply to the lips with a cotton swab. For a more magical feel, add teardrops under the eyes and white stars and tiny sparkles throughout.

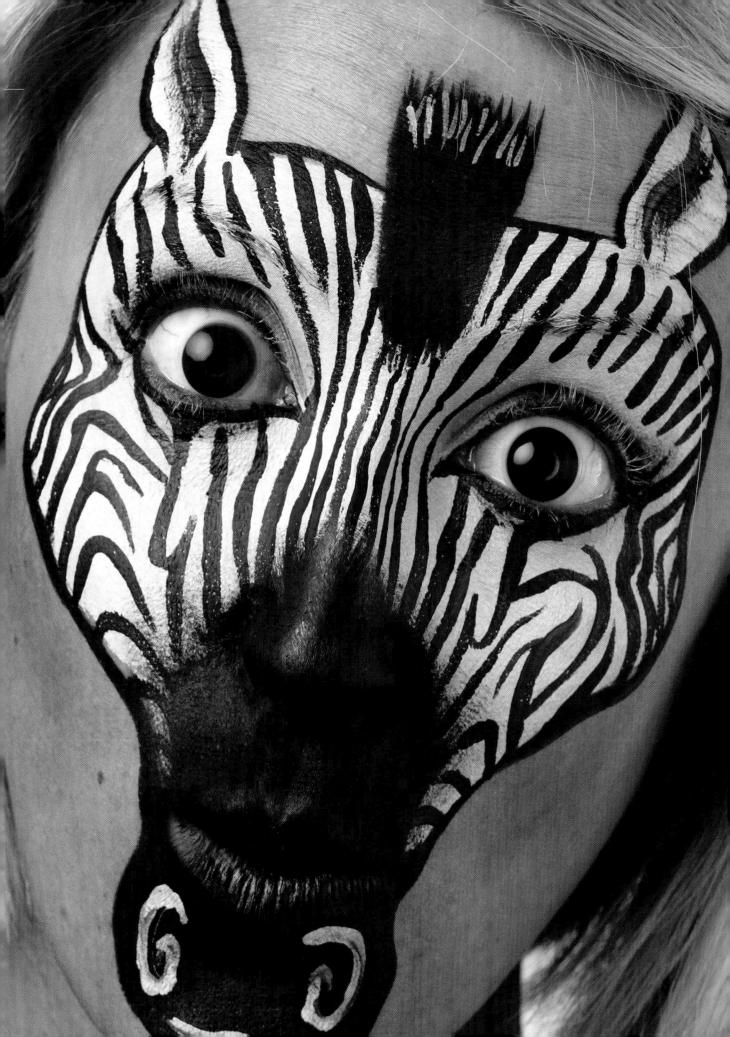

Zebra

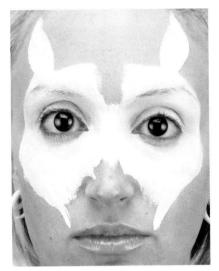

1 Using a sponge, apply white across the eyes, adding ears on the forehead and leaving a space for the mane on the bridge of the nose.

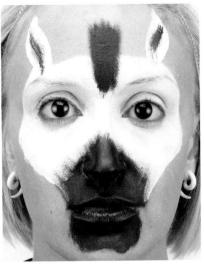

2 Apply black to the muzzle, nose and chin with a sponge, blending it into the white. Also lay in the mane and the insides of the ears.

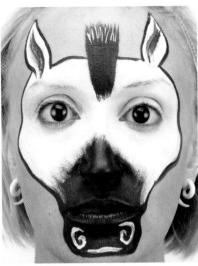

3 Outline the entire face and define the ears and mane using a no. 3 round and black.

With the same brush, highlight the mane with short brushstrokes of white, then draw nostrils and add a thin white line for the mouth.

4 Using your no. 3 round and black, begin establishing the stripe pattern, first adding thin to thick lines down the center of the face. Then add some stripes directly beneath the eyes, moving down across the cheekbones.

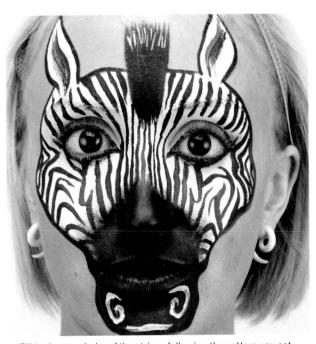

5 Fill in the remainder of the stripes following the pattern you set in step 4. Using the same brush, add more black eyeliner and shade the tops of the eyelids with a black and white mix.

white

≤ponge ± 3

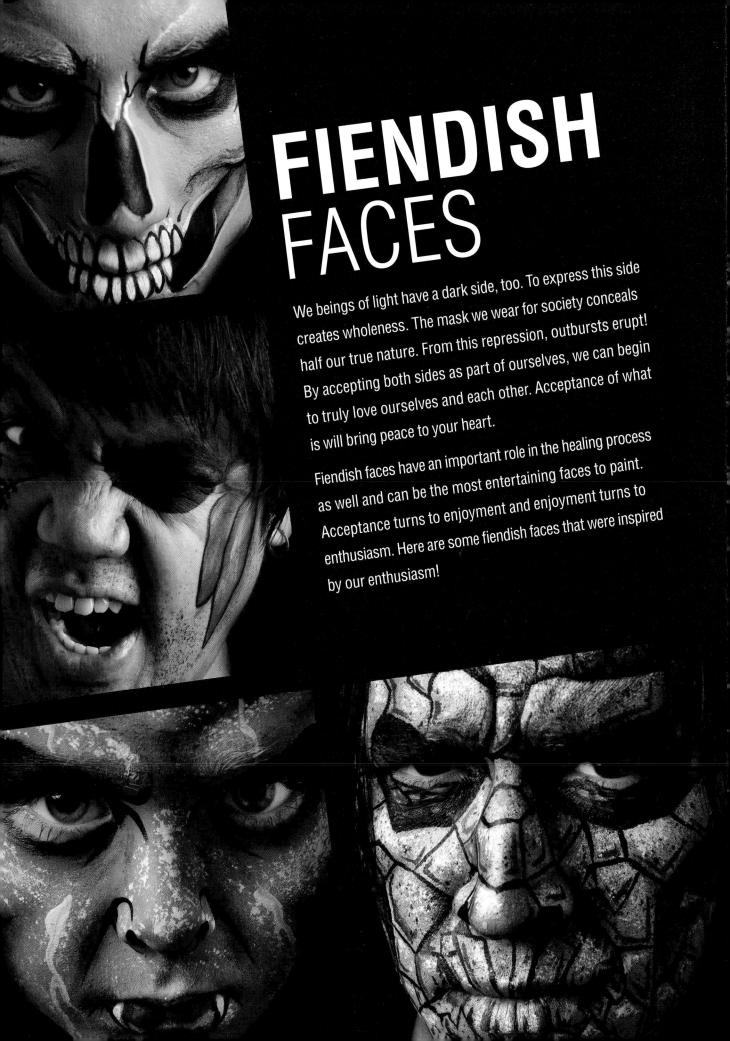

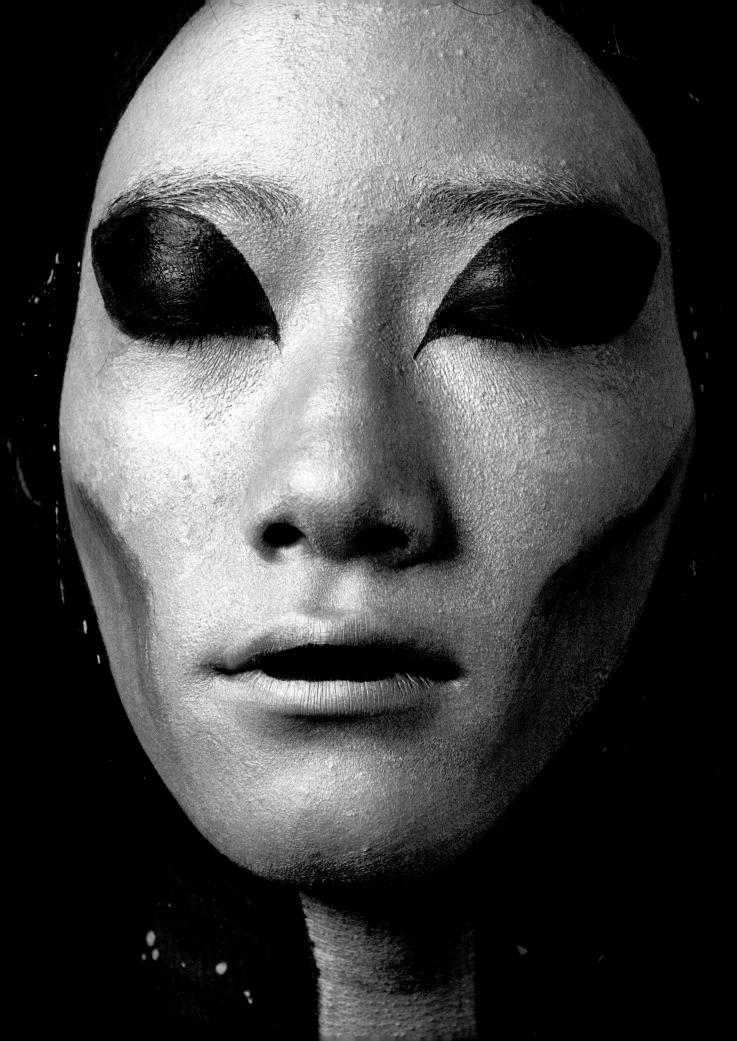

Alien

1 Mix silver with light green and apply it to the face and center of the neck using a sponge.

Outline and shape the alien head using a sponge and black. Create a background around the head and neck to make them appear thinner.

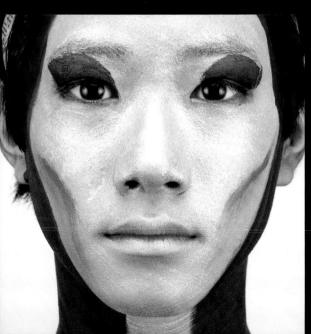

Use a sponge to add black to the eyelids and to shade the cheekbones.

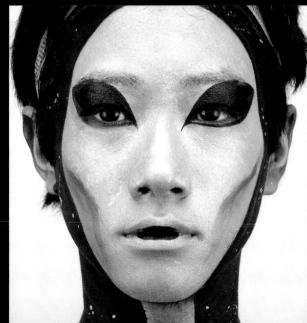

Use a no. 3 round and black to clean up the eyes and the outline around the face and neck. With the same brush and color, add a very thin, short lip line. Use a sponge and black to shade under the face at the top of the neck. Spatter white stars on the background with a card,

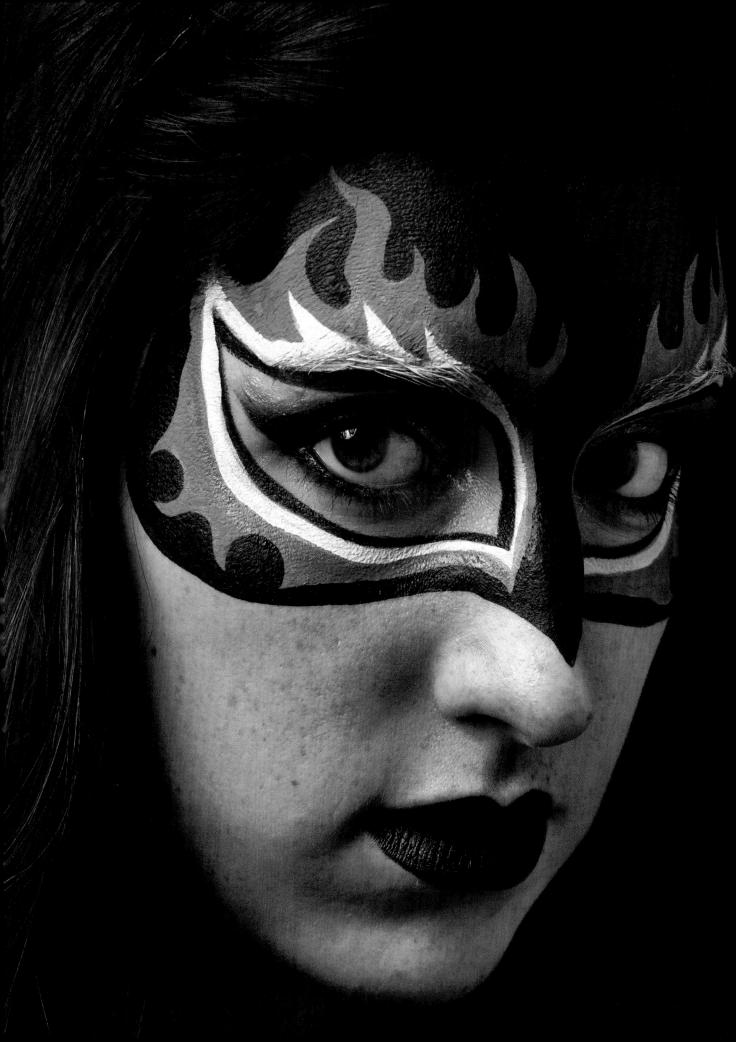

Bad Girl Mask

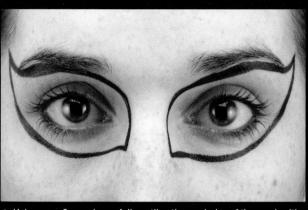

 \P . Using a no. 3 round, carefully outline the eye holes of the mask with black, keeping them as symmetrical as possible.

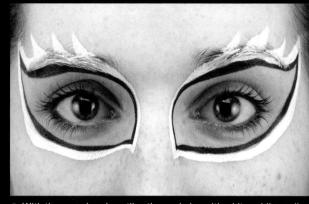

 ${\Bbb Z}$ With the same brush, outline the eye holes with white, adding spiky flares radiating from the top of the eyes and crossing the brow.

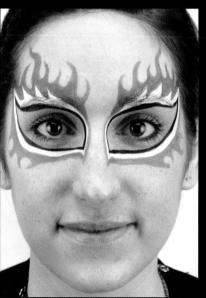

Outline the white border around the eyes using a no. 3 round and a mixture of neon pink and purple. Paint around the spikes and add a flame pattern as you go.

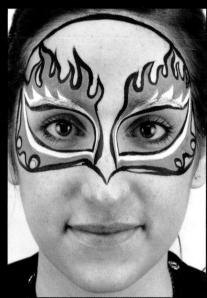

Using a no. 3 round, outline the edges of the purple flames with black. Then, add the outline for the mask, working from the center of the nose, up around the forehead and down the opposite side of the face.

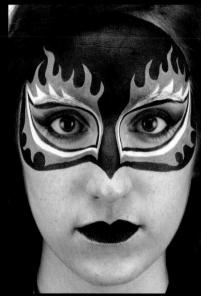

5 Using a no. 6 round, fill in the mask and lips with black. With the same brush, add metallic purple eye shadow across the eyelids. Line the eyes with black and the no. 3 round.

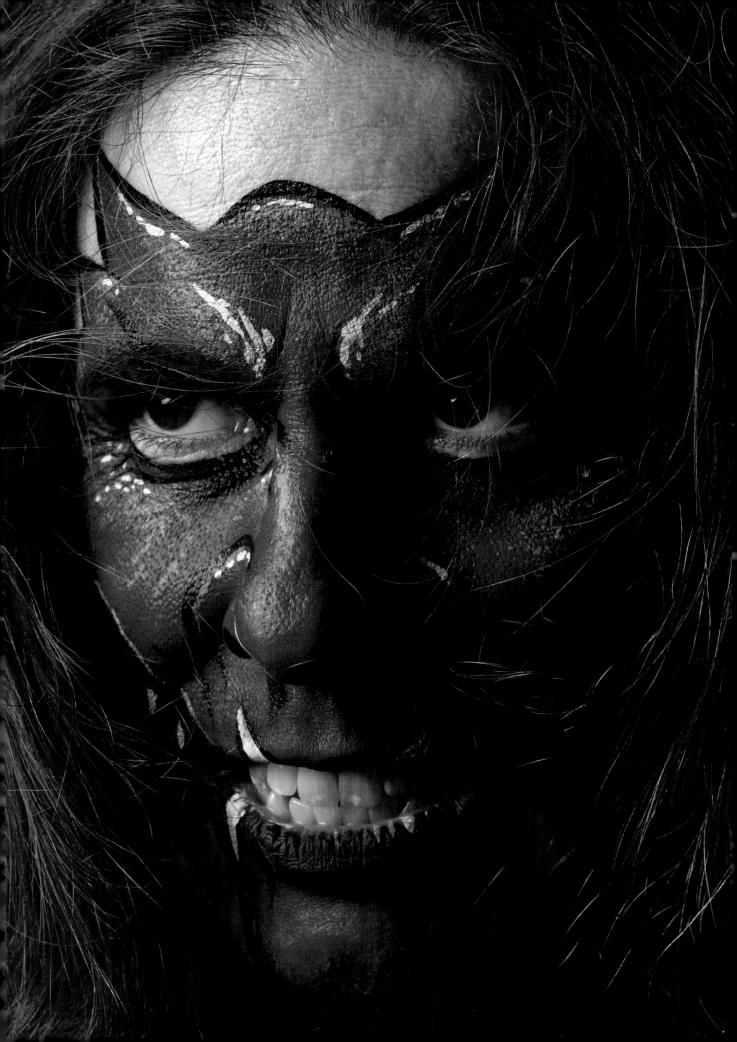

Beast

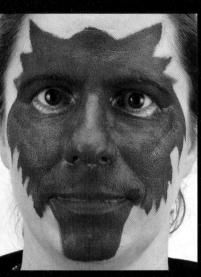

Apply a red basecoat to the face with a sponge, using the edge to keep the outside lines crisp. Paint from the center of the face outward, radiating toward the spikes of fur on the outer edges.

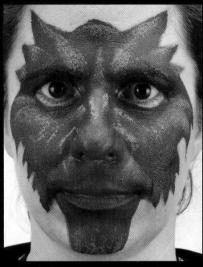

2 Stipple on tan with the corner of the sponge to highlight the fur and accent the cheekbones. Flip the sponge to the clean side to blend in as needed. Then, add brown to shade beneath the eyes, lower lip, jaw and horns.

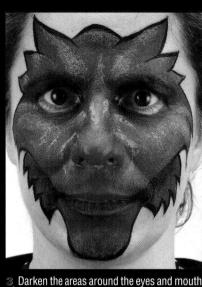

using a sponge loaded with black.
Then, outline the entire face in black using a no. 3 round.

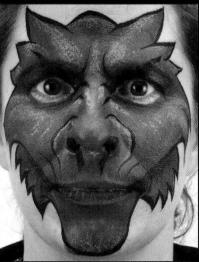

Define the eyebrows and add thin black lines using a no. 3 round to suggest the wrinkles on the bridge of the nose. Use the same brush and color to establish the nose shape and fill in the nostrils.

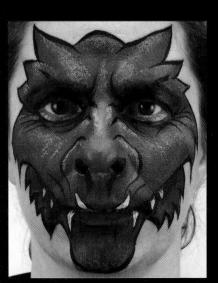

Add thin black lines with a no. 3 round to indicate the wrinkles around the eyes. With the same brush and color, add outlines of teeth and drippy lines from the mouth.

Then, paint in the teeth with white.

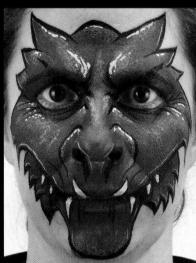

© With a no. 3 round and white, place highlights on top of the tan highlights, painting in broken strokes. Add a thin white line underneath the top jaw to separate it from the bottom jaw. Add off-white highlights on top of some of the white highlighted areas to create more deoth.

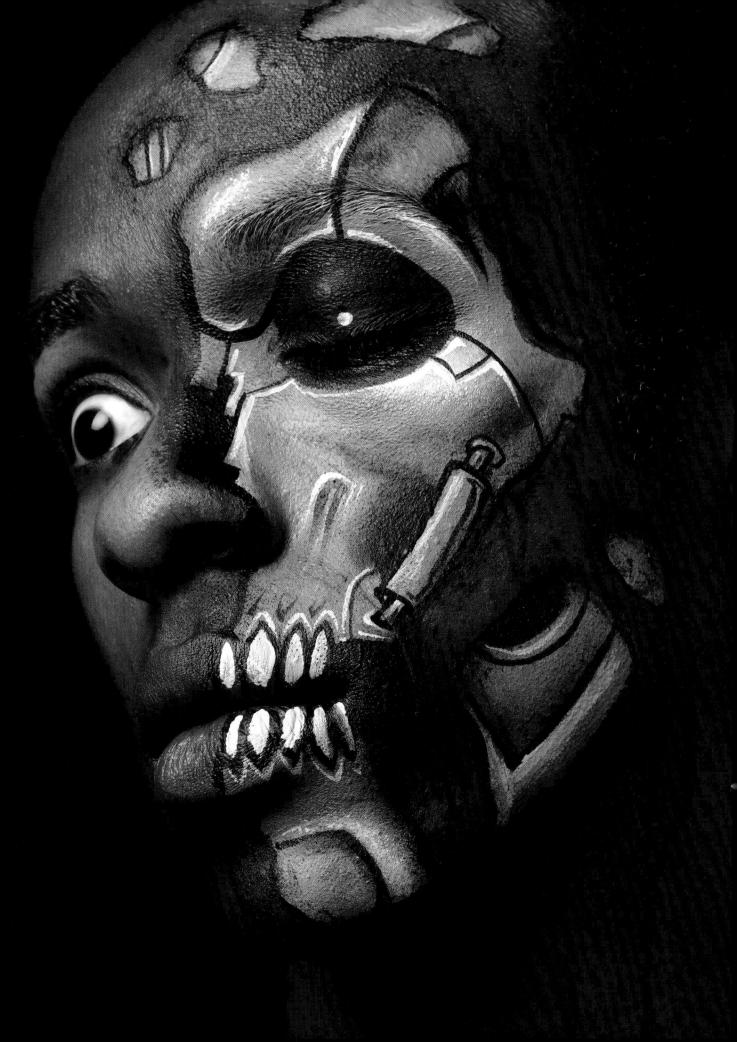

Cyborg

1 Use a sponge to stipple on gray, suggesting exposed metal around the left eye and in select spots along the forehead, cheek, jaw and chin.

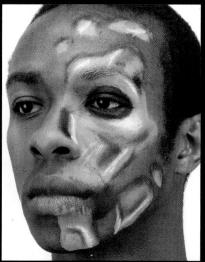

2 Add a black circle around the eye using a sponge. As the color dries on the sponge, shade above all the metal panels to make them look like they are sunken under the skin. Shade along the nose cavity.

Stipple on white highlights along the brow and cheekbone. Use the edge of the sponge to add highlights along the metal plates.

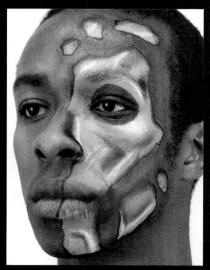

With a sponge, stipple on red around the plates to indicate wounds where the flesh has come away from the face.

Use a no. 3 round to clean up the eye hole edges and to outline the plates with black.

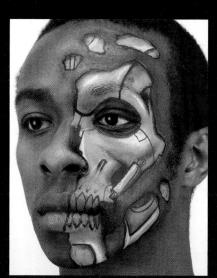

Use a no. 3 round and black to establish the mechanical pieces connecting the plates within the face and to add an outline of teeth.

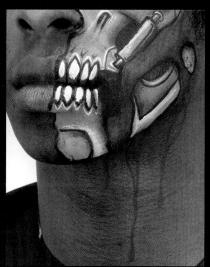

5 Fill in the teeth with off-white using a no. 3 round. Then add white highlights along one side of the black plate outlines. Using the same brush, add red blood drips,

moving your brush in wobbly lines.

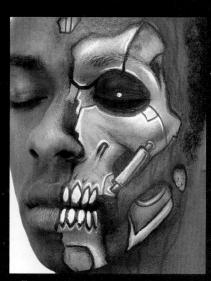

© To create the cyborg's eye, place a large red dot on the left eyelid using a no. 3 round. Once this dries, add a small, sharp white point to suggest the pupil.

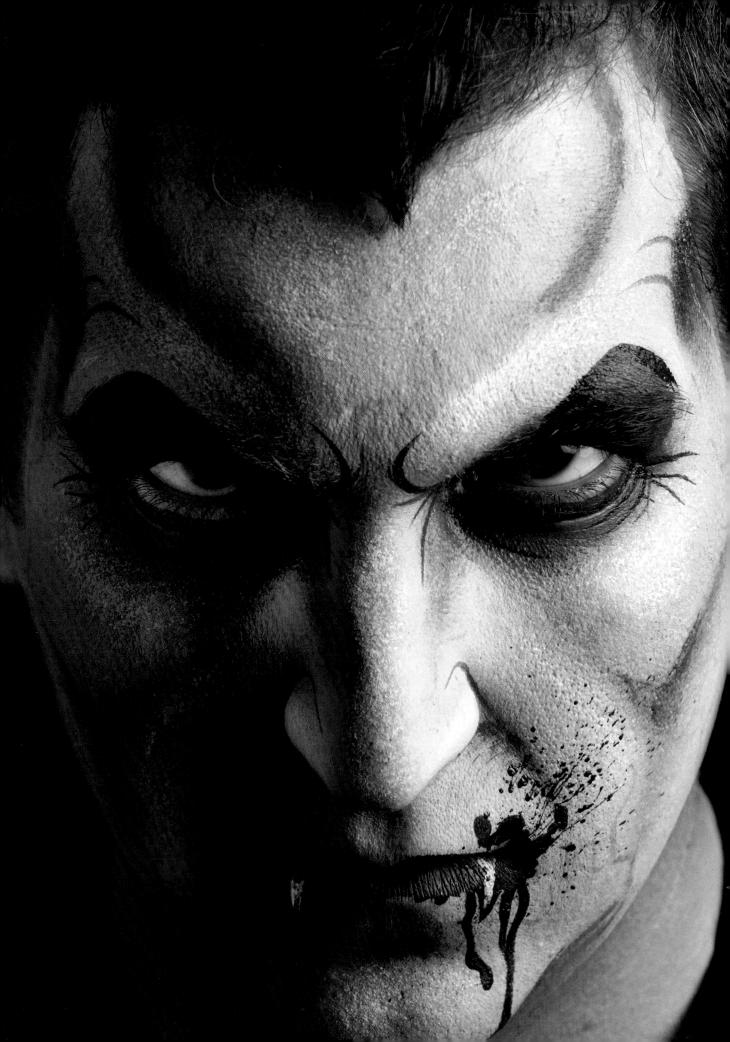

Dracula

Apply off-white to the face using a sponge. Then, immediately stipple the basecoat with the other side of the sponge to get the color as smooth and even as possible.

Mix purple and brown on a sponge to make a bruisy color. Apply this mixture around the eyes and mouth and along the cheeks. While the color is still wet, use the clean side of the sponge to drag it down, creating a more subtle effect. Shade the temples using the same materials and technique.

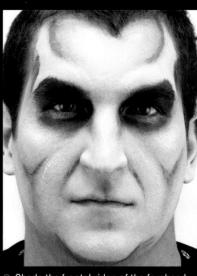

Shade the frontal ridge of the forehead and the divot over the lip with same color and sponge used in step 2. Then stipple in white highlights around the dark areas to add more dimension to the face.

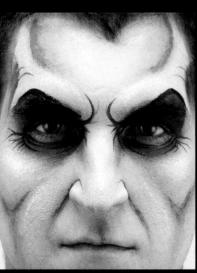

Add deep shading in the corners of the eyes and on the eyelids using a sponge loaded with black.

Define the eyebrows and add thin lines under and around the eyes to suggest deep wrinkles using a no. 3 round and black.

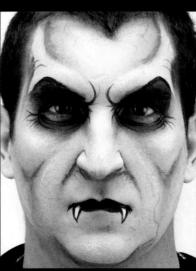

Paint the outline of fangs and the lips using a no. 3 round and black, then fill in the fangs with white. With the same brush and a mix of dark blue, apply thin, nearly transparent veins over the face.

Further define the nose shadow with a sponge and the bruisy color from step 2.

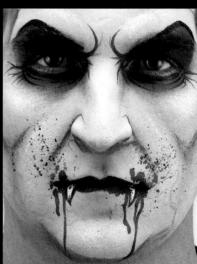

Using a no. 3 round and red mixed with a trace of black, wiggle your brush in a downward motion to create the blood drips around the teeth.

Spatter the blood red mix around the mouth using the card trick.

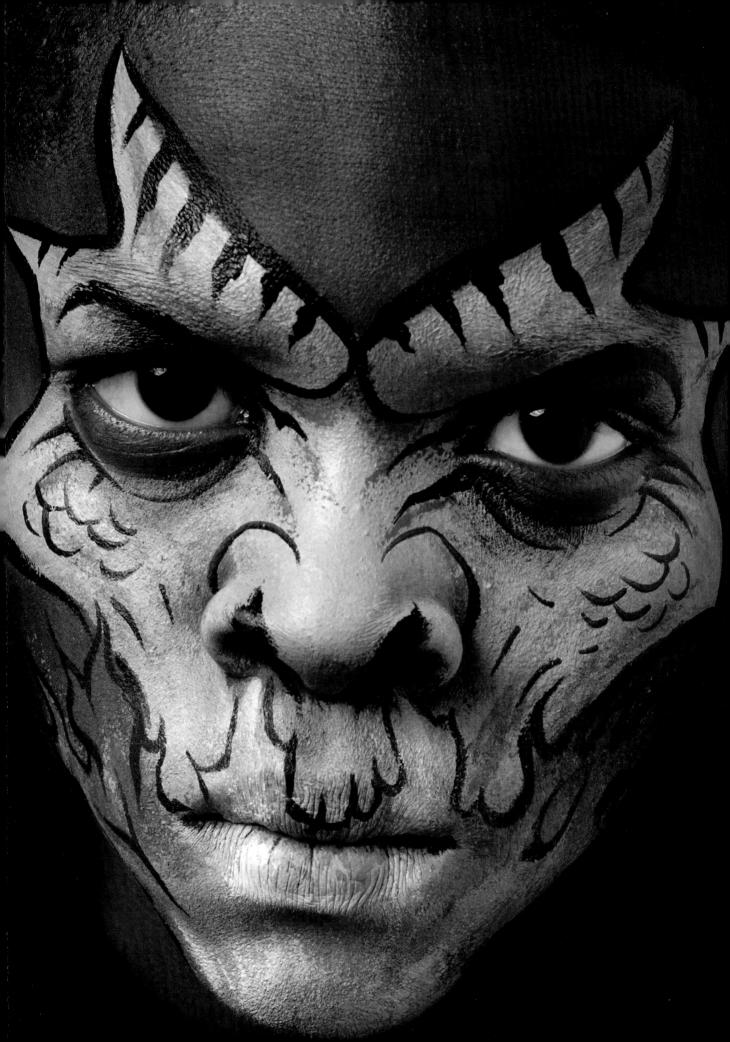

Dragon

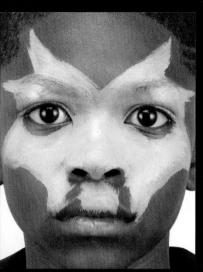

Using your sponge, apply a light green basecoat in the shape of a dragon face. Stipple in color to fill the shape evenly. Use a moist tissue to clean up around the edges if necessary.

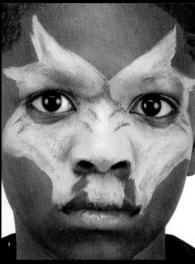

Shade around the eyes using a sponge and dark green. Use the edge of the sponge loaded with dark green to add wrinkles around the eves and nose.

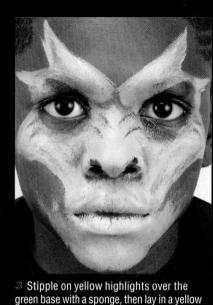

basecoat around the mouth and chin for the flames coming out of the dragon's nose.

Shade in the eyes with black and a sponge. Use a no. 3 round and black to add the nostrils.

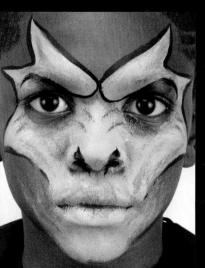

Stipple on orange flames over the yellow base using a sponge. Outline the facial features in black using

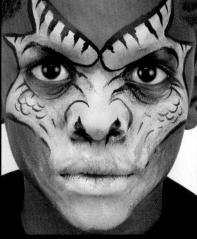

5 Deepen the wrinkles around the eyes and nose, and add scale shapes to the face using a no. 3 round and black. Continue placing details,

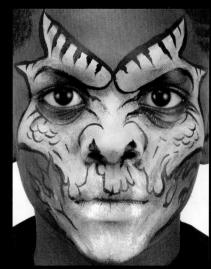

Outline the flames in red using a no. 3 round, then add white highlights to the flames with your brush and sponge.

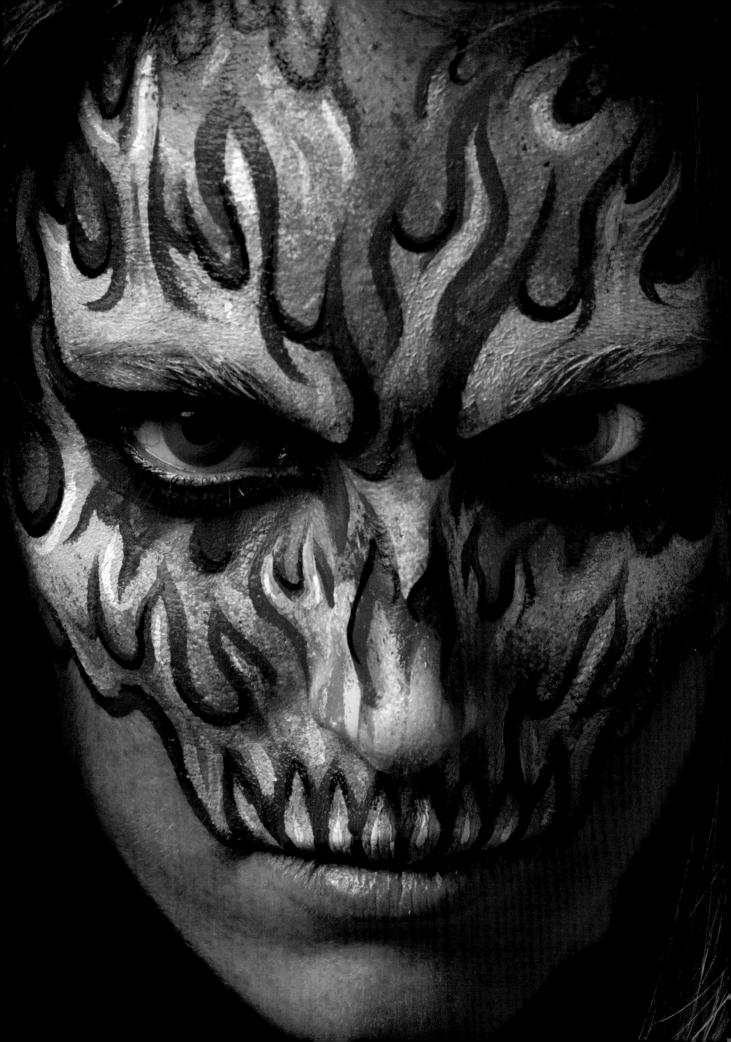

Fire Demon

1 Apply a yellow basecoat for the flames with a sponge, stippling on texture as you go.

Add orange to the negative spaces around the yellow with a sponge to further develop the flames.

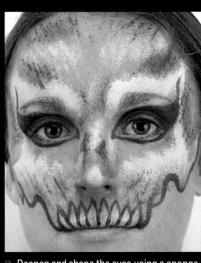

Deepen and shape the eyes using a sponge and red. Use red to stipple in more flames along the hairline, on the forehead and temples, and near the mouth. Use a no. 3 round to further exaggerate the shape of the eyes and sharpen the edges of your sponge work. Also add a line under the eyes, and outline the teeth and the bottom edge of the mask with red.

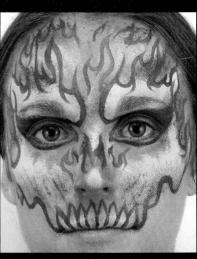

4 Begin detailing the flames, adding red outlines around the eyebrows using a no. 3 round. Add red shading and flame outlines around the nose using the same brush.

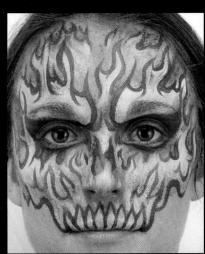

5 Continue to develop the flame shapes on the forehead and cheeks using a no. 3 round and red. With the same brush, add yellow highlights on the flames and fill in the teeth.

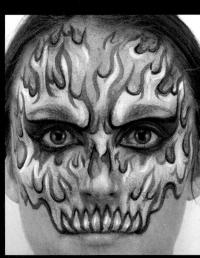

6 Line the eyes with black using a no. 3 round, then shadow the center of the flame shapes with thin black lines to deepen the darkest parts of the fire. With the same brush, add a black brow line over the red eye flames, and add white highlights to the brightest yellow areas of the flames and the teeth.

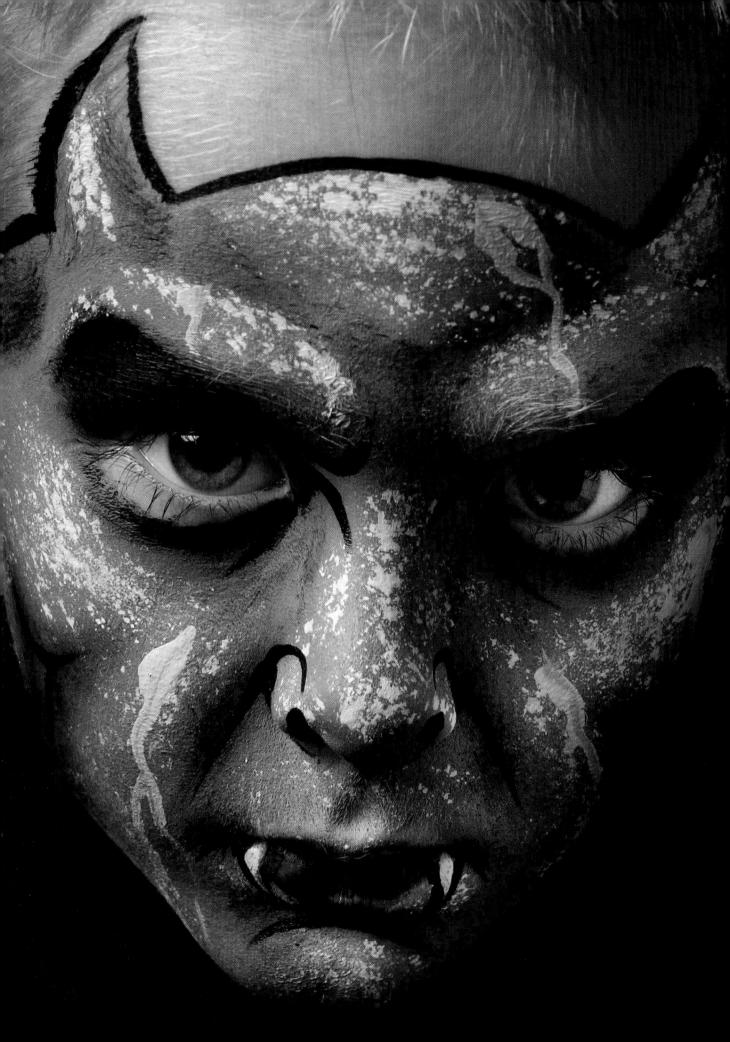

Gargoyle

Apply a smooth gray basecoat on the face and ears using a sponge.

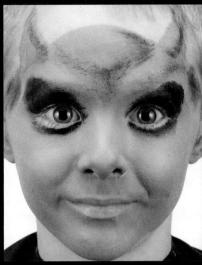

Shade in the eyes, horns and temples using a sponge and black.

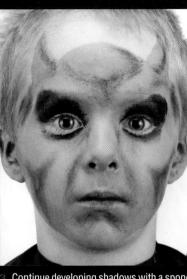

3 Continue developing shadows with a sponge and black, shading in the laugh lines, chin, cheeks, lips and ears.

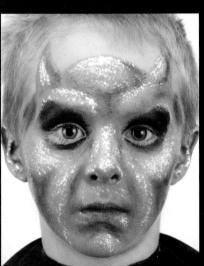

Using a sponge and white, stipple on highlights and add texture, carefully placing color in areas devoid of shadow. Remember, because you want to indicate the texture of stone, it's important that you *not* blend the white marks

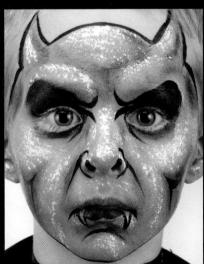

Use a no. 3 round and black to outline the face, and define the brows, nostrils and cheeks. Paint the lips and add outlines of teeth using the same brush and color.

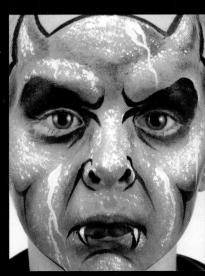

© Fill in the teeth with white using a no. 3 round. Also add white drip shapes down the surface of the face, suggesting aged and cracked stone, using the same brush.

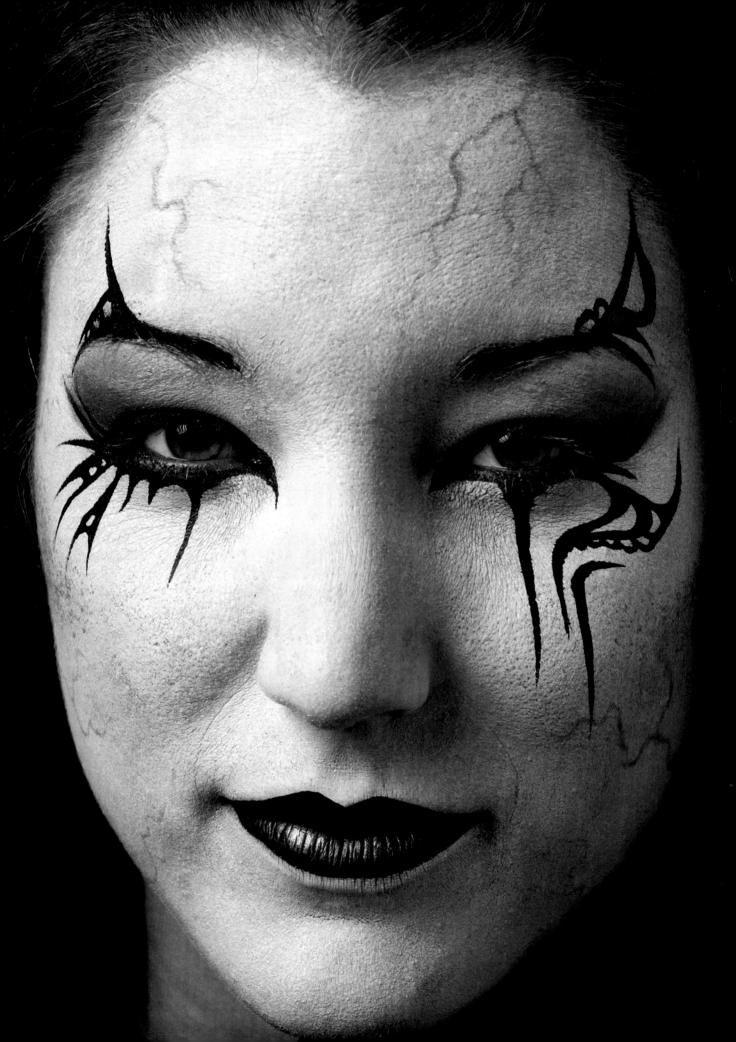

Goth Girl

Apply a white basecoat to the face using a sponge, first stroking and then stippling on the color to fill evenly.

Cover the eyes with powder blue using a sponge, work with the clean side to blend the color into the white. Apply metallic blue closest to the eye, extending past the corner of the eyes and curling upward.

Stipple gray blush on the cheekbones with a sponge. Then, using a no. 3 round, line both eyes

with black.

4 Add thin eyebrows and drawn on lashes using a no. 3 round and black.

Using a no. 3 round, develop the linework beneath the eyes, following the contour of the cheekbones. With the same brush, darken the corners of the lids with dark blue and add thin blue lines on the face to indicate veins.

© Continue developing the linework around the eyes, and add linework above the eyebrows using your no. 3 round and black.

Fill in the lips with black using a no. 3 round, then add metallic blue stripes down the lips to make them pop.

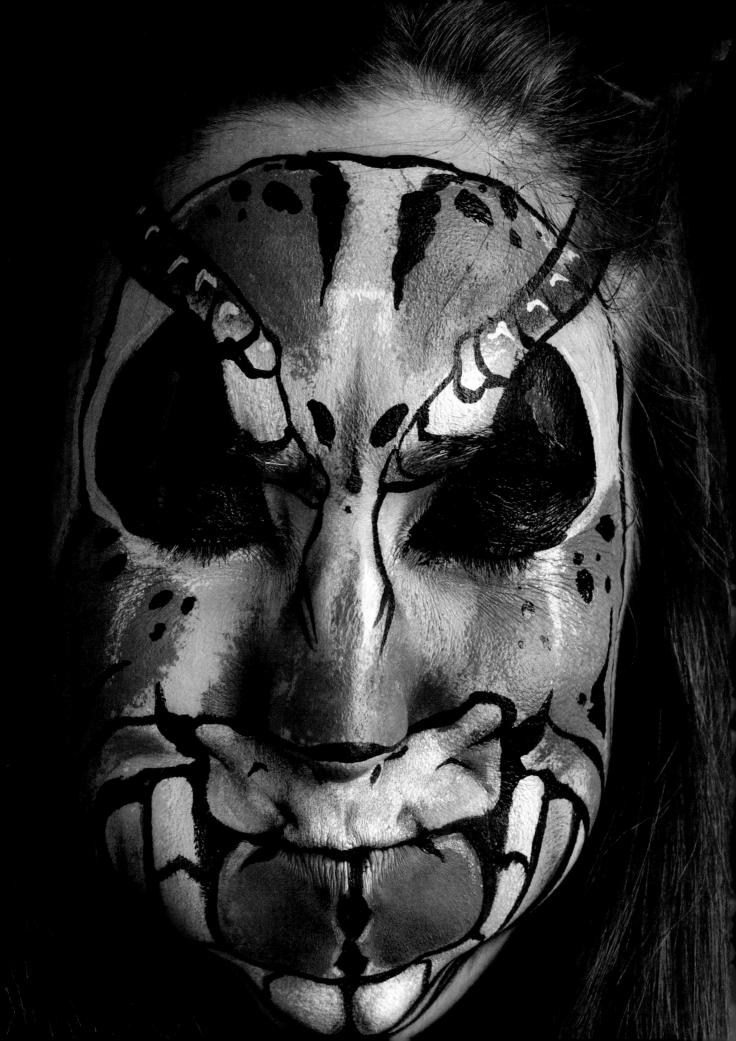

Insect

Apply a yellow basecoat to the entire face using your sponge.

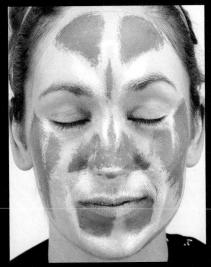

2 Apply orange faceplates with a sponge, then stipple on white highlights.

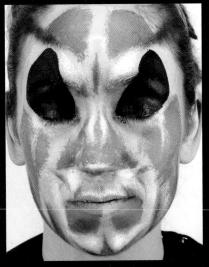

Add brown shadowing to the face and suggest the beginnings of brown antennae on each side of the forehead using a sponge. Add large black masses over the eyes using a sponge, then outline these shapes with a no. 3 round and black.

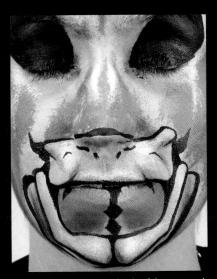

Add a thin line across the tip of the nose and outline the area between the mouth and nose using a no. 3 round and black. With the same brush and color, outline the lower jaw area and add details around the nose and mouth, using the side of the brush to create wider lines.

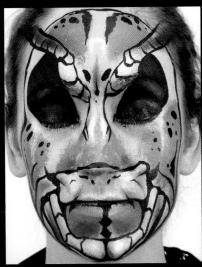

Using a no. 3 round and black, add more details around the entire face, paying particular attention to the jaw, forehead and antennae areas.

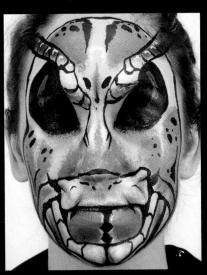

Add white highlights to the antennae and lower mandibles using a no. 3 round. Add purple highlights on the eyes with the same brush, stroking on the color as smoothly as possible.

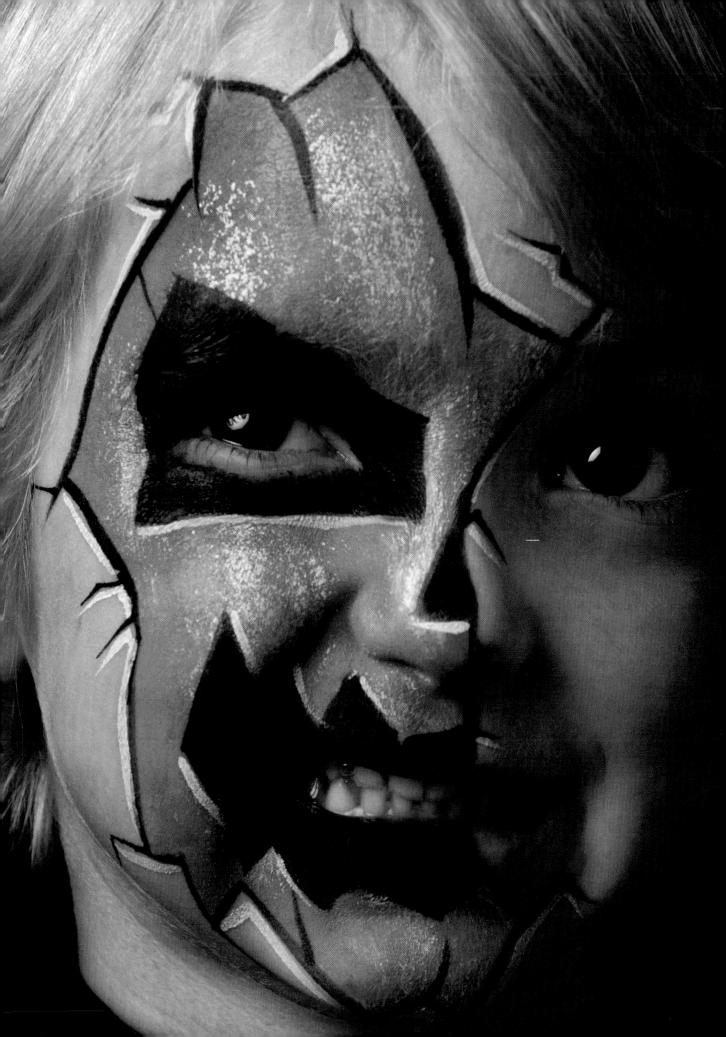

<u>Jack-o'-Lantern</u>

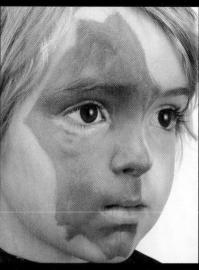

Apply an orange basecoat across the right half of the face, using a sponge to lay in a somewhat jagged geometric shape.

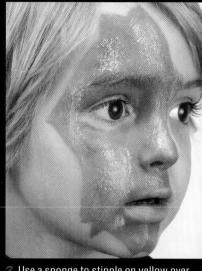

Use a sponge to stipple on yellow over the orange basecoat to indicate texture and add dimension.

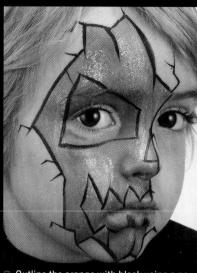

Outline the orange with black using a no. 3 round. Also outline the eye and suggest the teeth. Then, paint the grooves and cracks on the edges of the pumpkin face using the same brush and color.

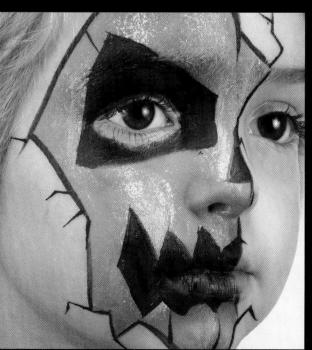

Fill in the eye with black using a sponge. Then, using a no. 3 round loaded with black, clean up the edges of the eye and fill in the nose

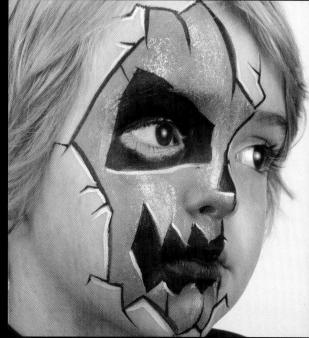

 $\ ^{5}$ Add white highlights around the features and cracks using a no. 3 round.

Mr. Hyde

Apply a teal basecoat to the right side of the face with the corner of a sponge, first stroking on color and then stippling to achieve an opaque layer. Leave an unpainted area where the snarl will appear.

A Mix dark green and blue to create a shadow color. Sponge the color onto the temple and around the eye, nose and chin areas. Use the edge of the sponge to lay in thin shapes, and use the clean side of the sponge to blend and soften.

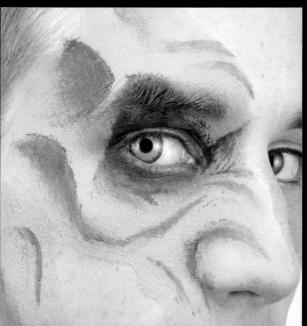

Sponge purple around the eye to deepen the socket. Also add a little purple to the darkest shadows on the temple and around the nose.

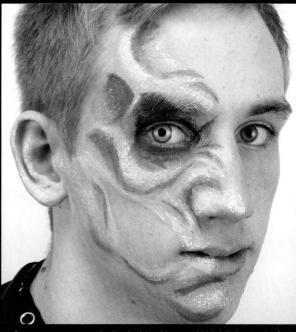

Sponge on some teal mixed with white to add highlights to the facial features and indicate texture. Add a little yellow on top of the white to make the highlights pop.

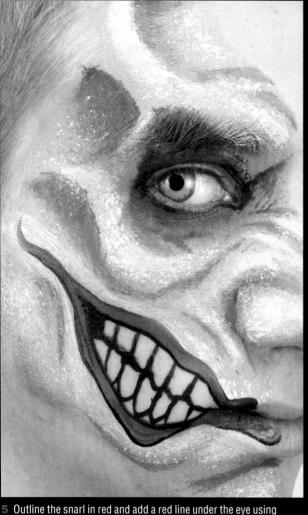

Suggest the teeth, outlining them in black with your no. 3 round. Fill in the space between the top teeth and bottom teeth using the same brush and color.

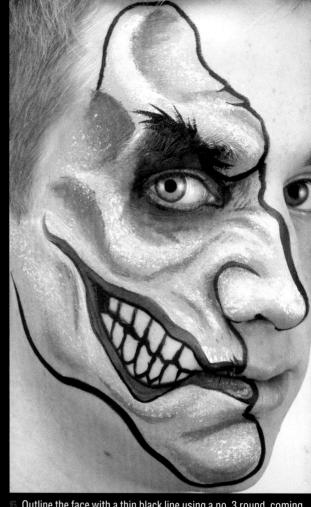

© Outline the face with a thin black line using a no. 3 round, coming up around the forehead, down the nose and lips, and back around the chin. Add the eyebrow with the same brush and color, using short thin strokes radiating up from the model's natural brow.

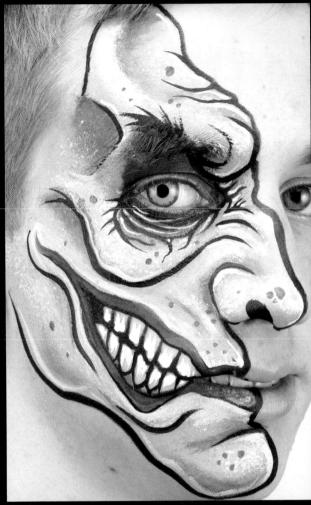

We use a no. 3 round and black to add wrinkles to the face. With the same brush, color in the top half of the teeth with white. Also place white highlights along the black outlines you added in the previous step. Still using a no. 3 round, paint the gum line hot pink and add some festering sores to the face.

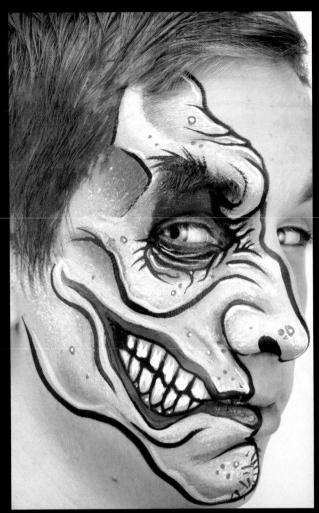

Add small white dots to the gums and sores using a no. 3 round. Sponge an orange-brown mix on half of the hair, then use a no. 3 round to add hair to the face, coming down in short strokes from the hairline. Add a few whiskers on the tip of the chin and on the eyebrows using the same brush and color.

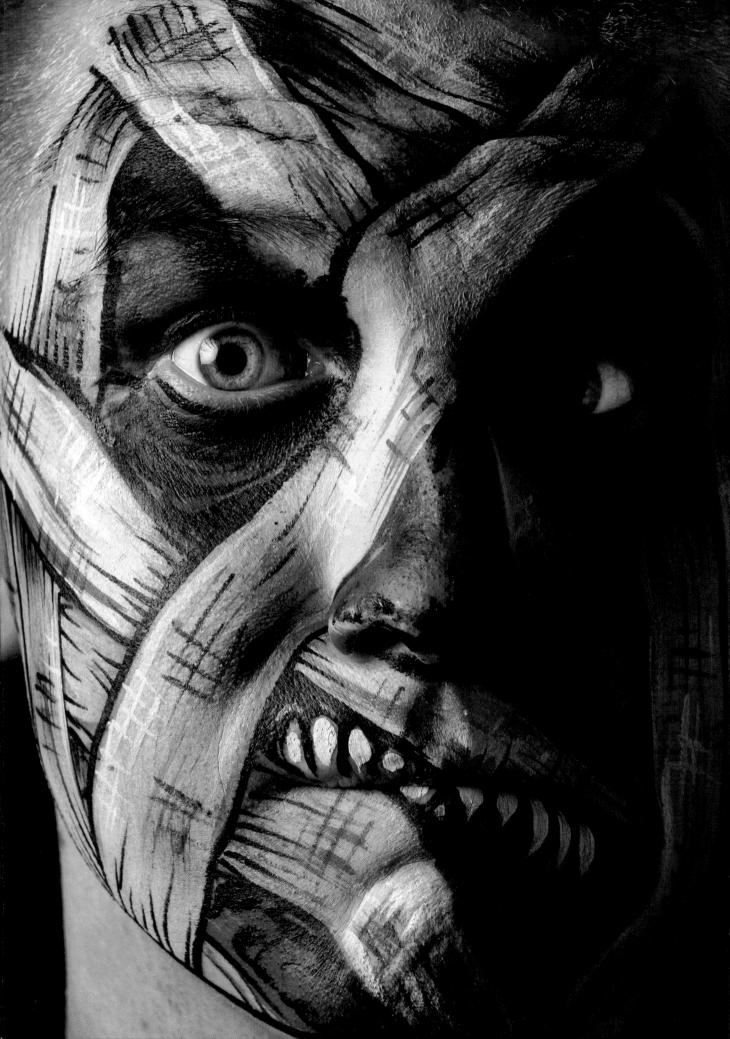

Mummy

Load a sponge with off-white and stroke on bandage shapes. Use the dry end of the sponge as needed to lift color if the bandages get too thick or run into one another too much.

 $\,\,^{2}$ Load a sponge with brown and fill in the space around the eyes, the nose and select areas around the chin to suggest skin showing through.

Continue to develop the skin showing through the gaps in the bandages using the edge of the sponge and brown. As the color continues to dry on the sponge, use it to lightly graze over the bandages to give them an aged appearance.

Apply black in the corners of the eyes and on the nasal cavities using a dry sponging technique. Also, dirty up the bandages to give them dimension, stroking on the color in the same direction as the bandages.

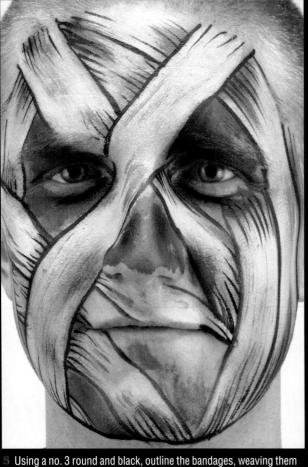

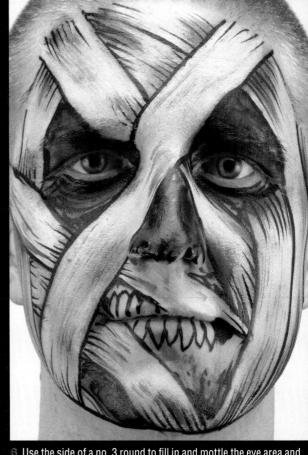

over and under each other.

Place thin black detail lines on the bandages where they overlap and intersect to emphasize their direction.

6 Use the side of a no. 3 round to fill in and mottle the eye area and add wrinkles. Add outlines of the teeth with the tip of the same brush. Place similar brushstrokes on other areas on the face to give the skin more texture.

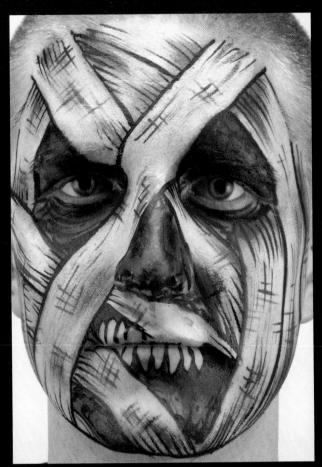

 $^{\prime\prime}$ Use dark brown and a no. 3 round to add crosshatch marks on the bandages. Then, using the same brush loaded with dark red, rough in the gum line.

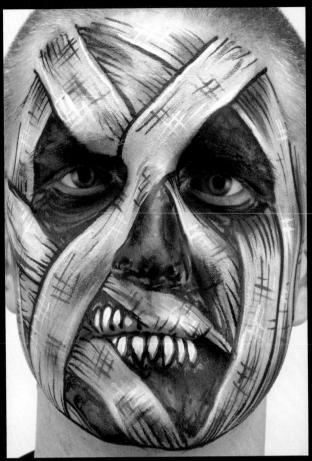

Add white highlights to the teeth and some of the black outlines along the bandages using a no. 3 round. For added texture, place white crosshatch marks on the bandages in areas devoid of black crosshatch marks. Add subtle white highlights to the gums using the same brush.

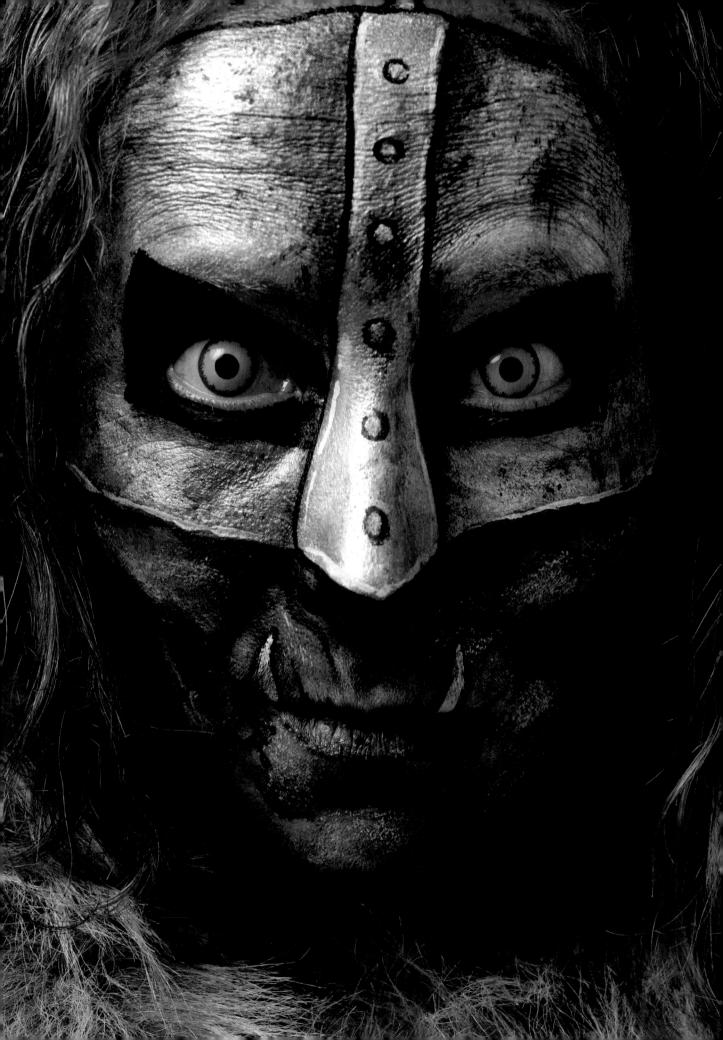

Orc

Apply the silver helmet shape with a sponge, first stroking on the color and then stippling to fill in the shape. Use a no. 3 round to define the bottom edge of the helmet.

If you'd like colored contacts for added effect (like the model here), have the model put on the lenses before you begin painting to avoid any runs or drips in the makeup.

Add a basecoat over the eye holes and develop the nose shape using a sponge loaded with black. Also tap in black around the face, scuffing the skin, emphasizing the chin, and dirtying the ears and face.

Then, indicate texture on the helmet using the edge of a sponge dipped in black.

Sloppily stipple brown onto the face, smearing it into the black with a sponge. Stipple brown onto the helmet here and there to suggest rust. Go back in with black as needed to redefine the darks, and use a moist towel or tissue to lift color where necessary.

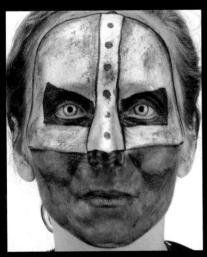

Use a cotton swab loaded with black to dab in the circular rivets on the helmet. Then use a no. 3 round to outline the helmet, softening the lines with a cotton swab.

Continue filling in the empty spots around the eyes and cleaning up the face using a no. 3 round and black.

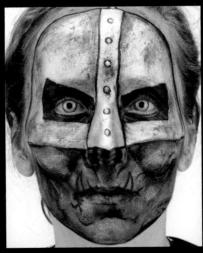

5 Place white highlights on the face using a sponge, and apply white to the rivets with a cotton swab.

Use a no. 3 round loaded with black to outline the jaw, add the teeth and place details on the cheeks and nose. Mottle with the side of the brush to maintain the effect of dirty skin.

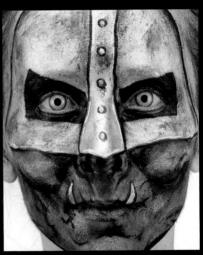

6 Color in the teeth and add highlights along the bottom rim of the helmet and bridge guard using a no. 3 round and white.

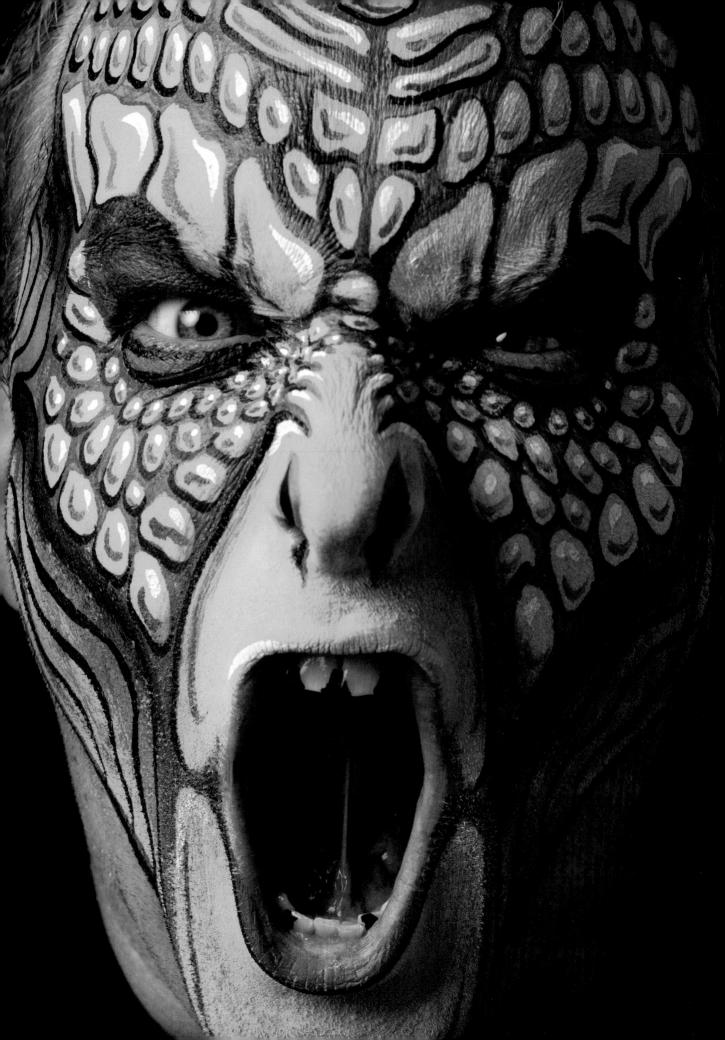

Reptile

 Apply a neon green basecoat to the entire face using a sponge.

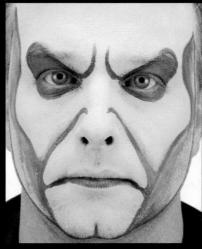

Shadow the eyes and temples with dark green using a sponge, making the face more reptilian. Use a no. 3 round and more dark green to sharpen the edges of the shadows and outline the face, lips, chin and laugh lines.

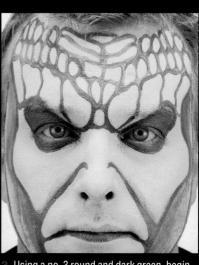

Using a no. 3 round and dark green, begin outlining scales on the forehead. Place the largest scales directly on the brow line, making them smaller as you work up toward the hairline. Stagger rows so they don't line up.

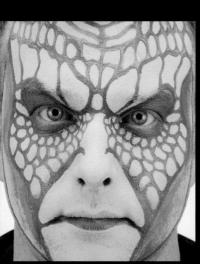

Using the same brush and color, add smaller scales under the eyes. Follow the eye shape and stagger the scales from row to row so they don't line up evenly.

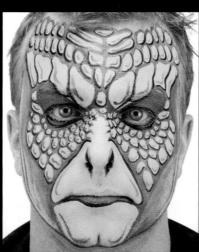

Add more scales to the sides of the nose using a no. 3 round and dark green. Add nostril slits and lines around the mouth and chin using the same brush and color. With the same brush, define the facial features, filling in the nostrils and outlining the lips, eyes and laugh lines in black. Add a thin black line under each scale with the same brush.

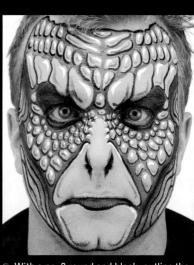

With a no. 3 round and black, outline the face and add wrinkles to the temples and jawline. With the same brush, add white highlights to the top of each scale; place circular shapes on smaller scales and teardrop shapes on larger ones. Add thin white lines around the nose and lower mouth area and on the top lip. Mix dark green with black and apply it to the eyes, the temple and under the cheekbone.

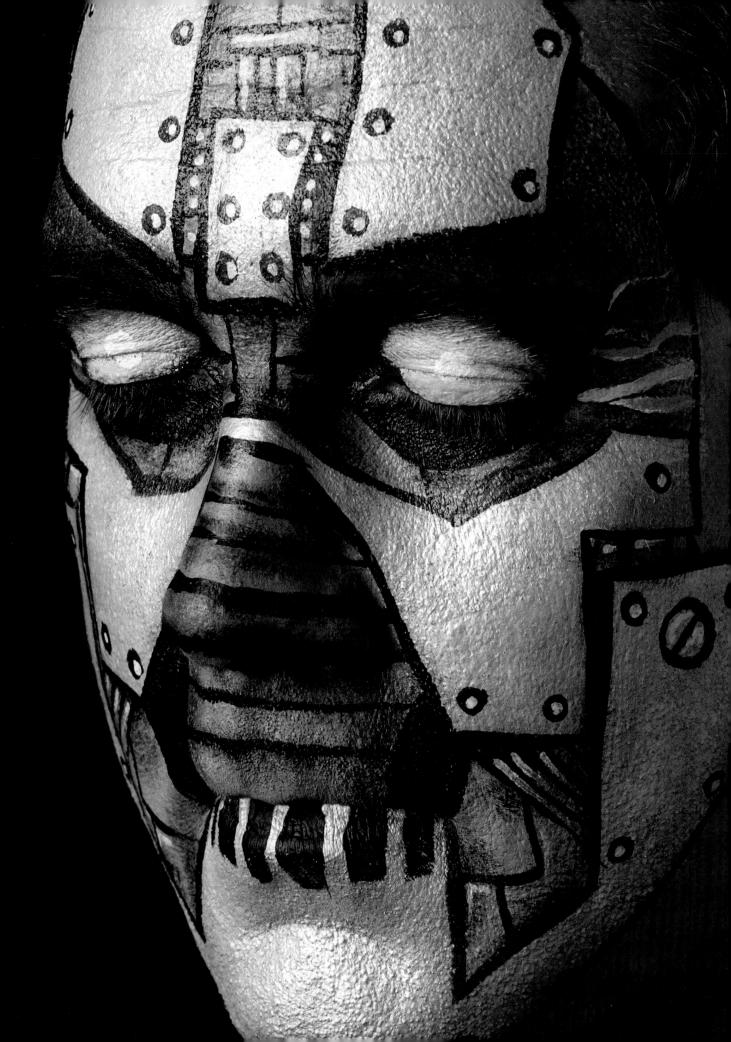

Robot

Apply a gray basecoat to the entire face, first stroking on color and then stippling to fill in and achieve an opaque effect. Leave some area around the eyes free from paint.

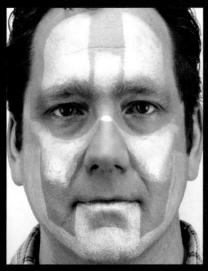

Stipple on silver plates, using the edge of the sponge for the thinner areas.

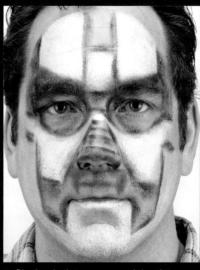

Shadow in the areas around the plates with black using the edge of the sponge. Also enlarge the eye sockets to give them distinct shapes.

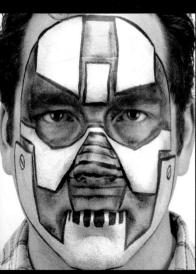

Use a no. 3 round to outline the silver plates with black. With the same brush and color, begin developing the facial features. Horizontal lines help hide the nose and screws along the jawline suggest a hinge.

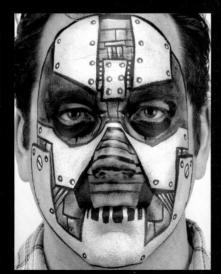

Add more mechanics to the forehead and more black around the eyes with a no. 3 round. Develop the darks with more shapes, and use a cotton swab to add rivets around the plates.

Add white highlights on top of the rivets and within the mechanics using a no. 3 round.

Sponge on hints of white along the outside of the eves and on the lids as a basecoat for

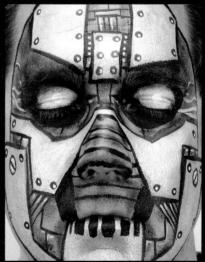

Add blue, red and yellow wires around the eyes using a no. 3 round. It's okay if some of the white basecoat shows through—it will look like highlights.

Mix light green with neon yellow and apply it to the eyelids using a sponge. To finish, use a no. 3 round to add white highlights on the lids.

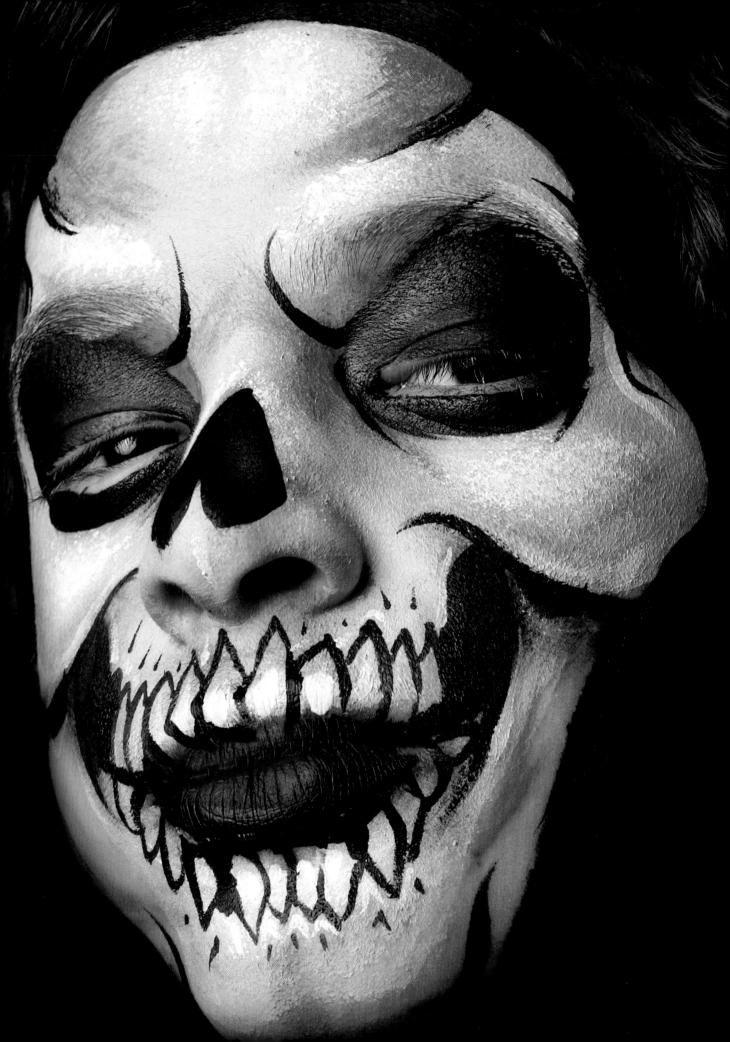

Skeleton

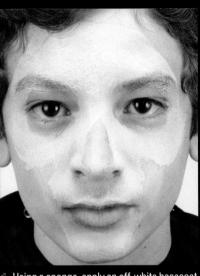

Using a sponge, apply an off-white basecoat on the forehead, cheeks and jaw, painting around the nasal cavity.

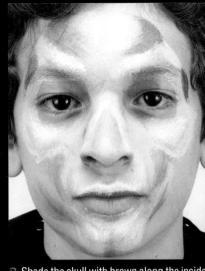

Shade the skull with brown along the inside of the eyes, the forehead, and around the mouth and chin using a sponge. Then, highlight the edges of the nose, cheeks, forehead and chin using a sponge and white.

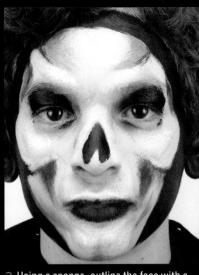

⇒ Using a sponge, outline the face with a thick black line, carving in the skull shape. Also shade the cheeks and fill in the nasal cavity, lips and eyelids using the same color.

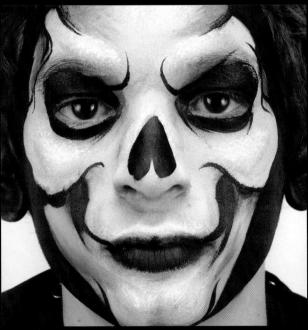

4 Outline and add more details to the skeleton face. Clean up edges to make them crisp using a no. 3 round and black.

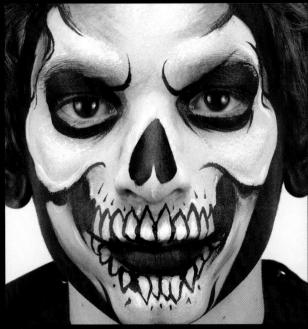

Continue detailing the face with a no. 3 round and outline the teeth. This is for an open-mouthed skeleton, so be sure to keep the teeth fully visible. Use white to fill in the teeth and highlight the bones, placing thin lines next to the darkest areas.

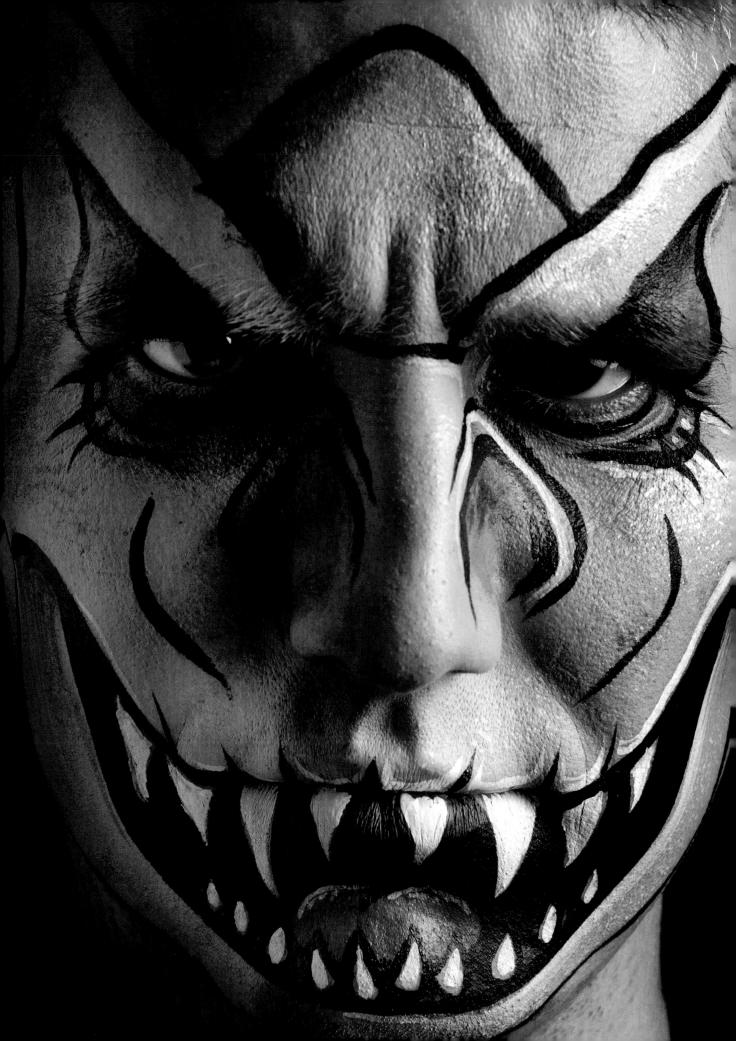

T-Rex

4 Lay in a light green basecoat with a sponge, making sure to paint around what will become the dinosaur's mouth.

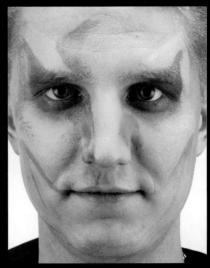

Add dark green shadowing around the eyes, nose, eyebrow and temple, and along the top jaw using a sponge. Then stipple yellow highlights on the left side of the face.

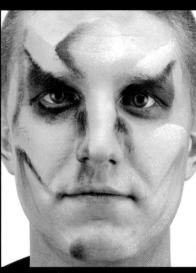

With a sponge, stipple white highlights on top of the yellows. Think of it like a sunburn—wherever you get burnt first is where the brightest highlights will be. Also darken the shadows you painted in step 2 by sponging on some black.

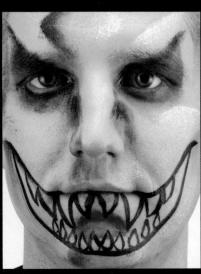

Sponge a dab of red beneath the lips to suggest the dinosaur's tongue. Then use a no. 3 round and black to outline the mouth and add outlines of teeth, being careful not to obscure the tongue.

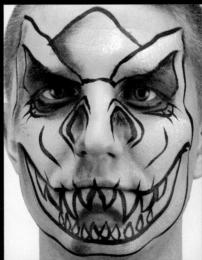

Outline the entire face with black using a no. 3 round. Define the eyes and the section of the forehead with the same brush and color. Then, add crow's feet around the eyes and wrinkles on the top lip, and indicate the nostrils beside the nose.

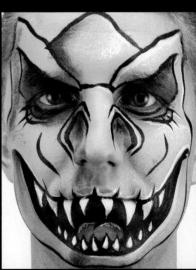

Fill in the negative spaces between the teeth with a no. 3 round loaded with black. Shape the tongue as you work. Paint the teeth white, and add white highlights along the top of the tongue with the same brush.

Add white lines around the features on the left side of the face using your no. 3 round to suggest more highlights.

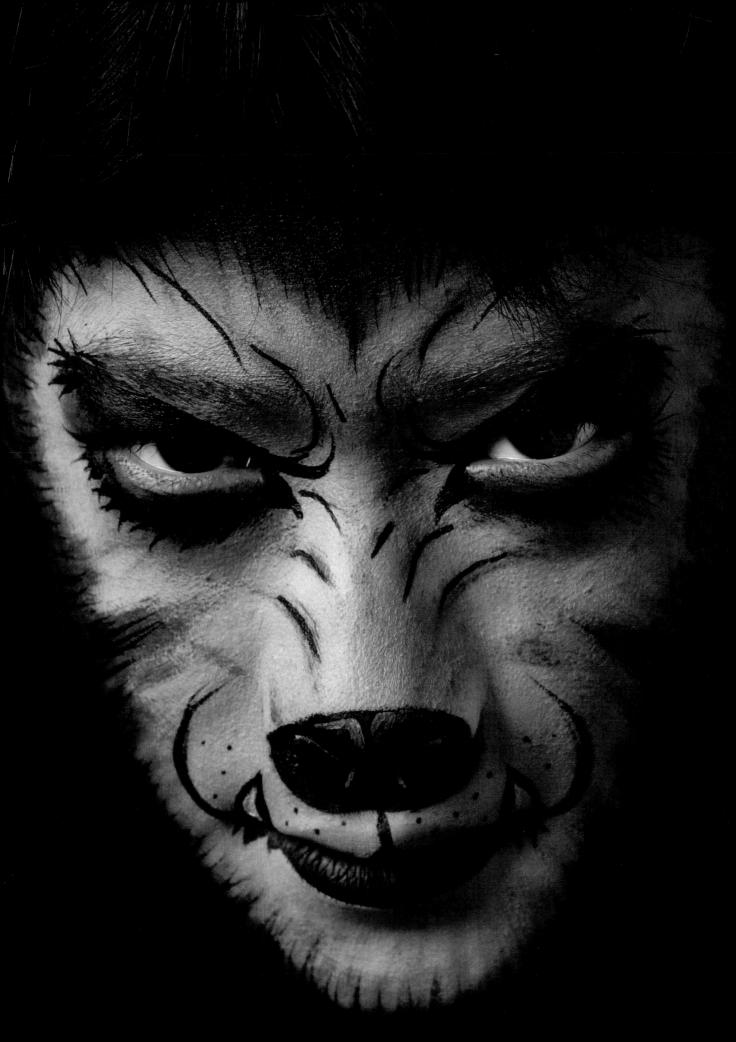

Werewolf

¶ Working in a heart shape, apply a basecoat of goldenrod to the face using a sponge.

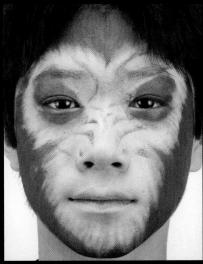

Add brown on the eyelids with a sponge and drag it out a bit to blend and create the appearance of fur. Apply the same color around the outer edge of the face, again dragging the sponge to suggest fur. Use the edge of the sponge to add the brow and nose wrinkles and shade under the eyes.

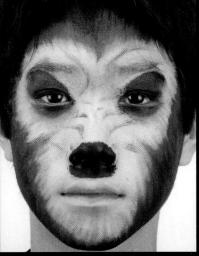

Using a sponge, apply black fur strokes right over the brown at the outer edge of the face. Use the edge of the sponge to fill in the brows, then paint the werewolf's nose on the tip of the actual nose as well as beneath it to extend the nasal cavity and create the illusion of a snout.

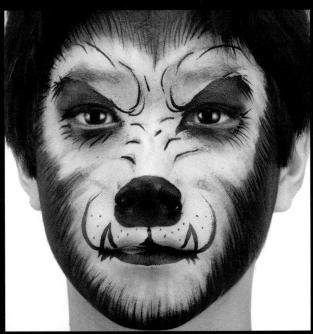

Paint the fur using a no. 3 round and black, dragging the brush from the outside in toward the face. Define the wrinkles, teeth and nose with thin linework.

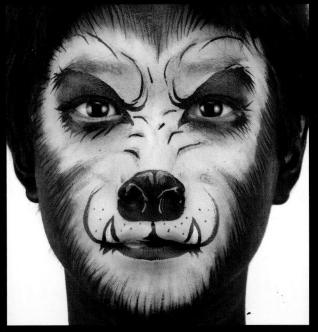

Whiten the teeth and add highlights to the nose using a no. 3 round. Black in the ears and neck with a sponge to complete the look.

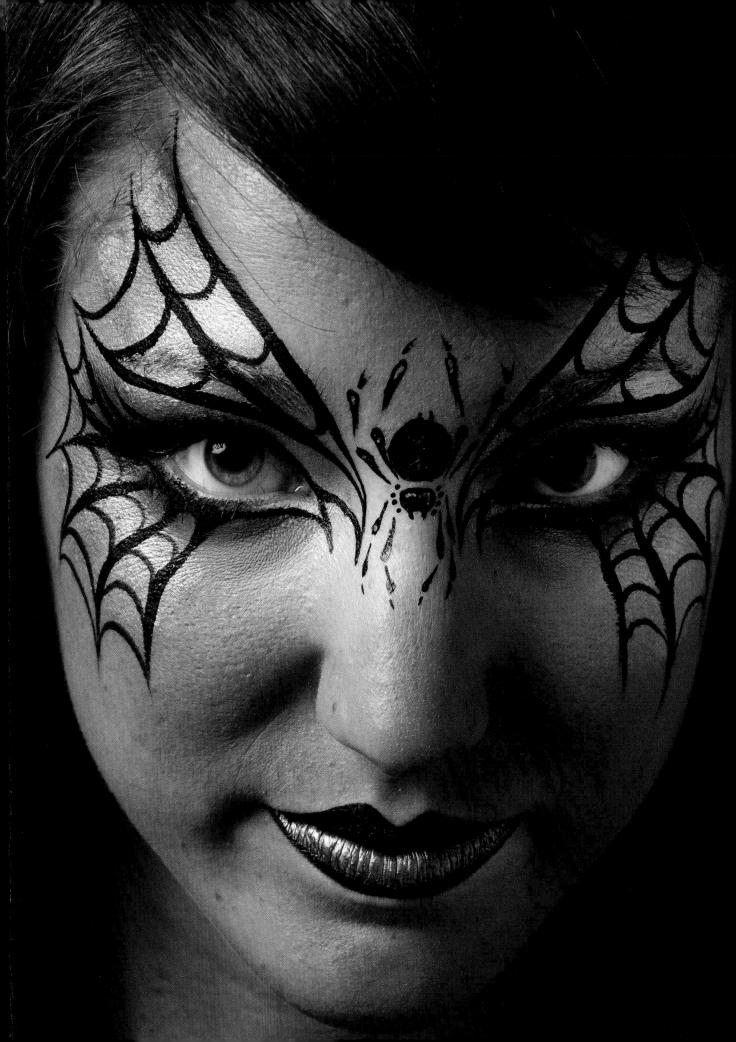

Widow Spider

1 Apply a silver basecoat across the eyes with a sponge, creating two wing-like shapes.

Apply metallic purple around the eyes using a sponge. Stipple to blend the color into the silver and drag the sponge through the basecoat to begin defining the web. Shade the lids of the eyes with black, working the color into the creases. Use the clean side of the sponge to blend the black into the purple.

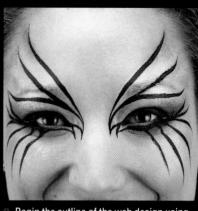

Begin the outline of the web design using a no. 3 round and black. Start with the lines above the eyes, pulling your brush from the inside out toward the edge of the face. Then add the linework beneath the eyes, pulling your brush in a downward motion.

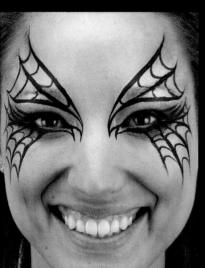

Finish the web outline using the same brush and color. Connect the existing lines together, adding short curved strokes between the lines to create a webbed pattern. Notice these strokes curve in an upward motion above the eye, while they curve in a downward motion

beneath the eve.

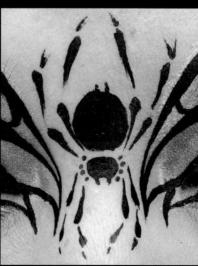

5 Use a no. 3 round and black to paint the spider's head and body between the eyes. Add four dots on each side of the thorax, then add the spider legs as a series of teardrop shapes.

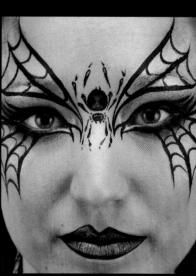

Add a red hourglass to the body of the spider for extra effect using a no. 3 round. Outline the lips in black, then fill them in with metallic purple using a no. 3 round.

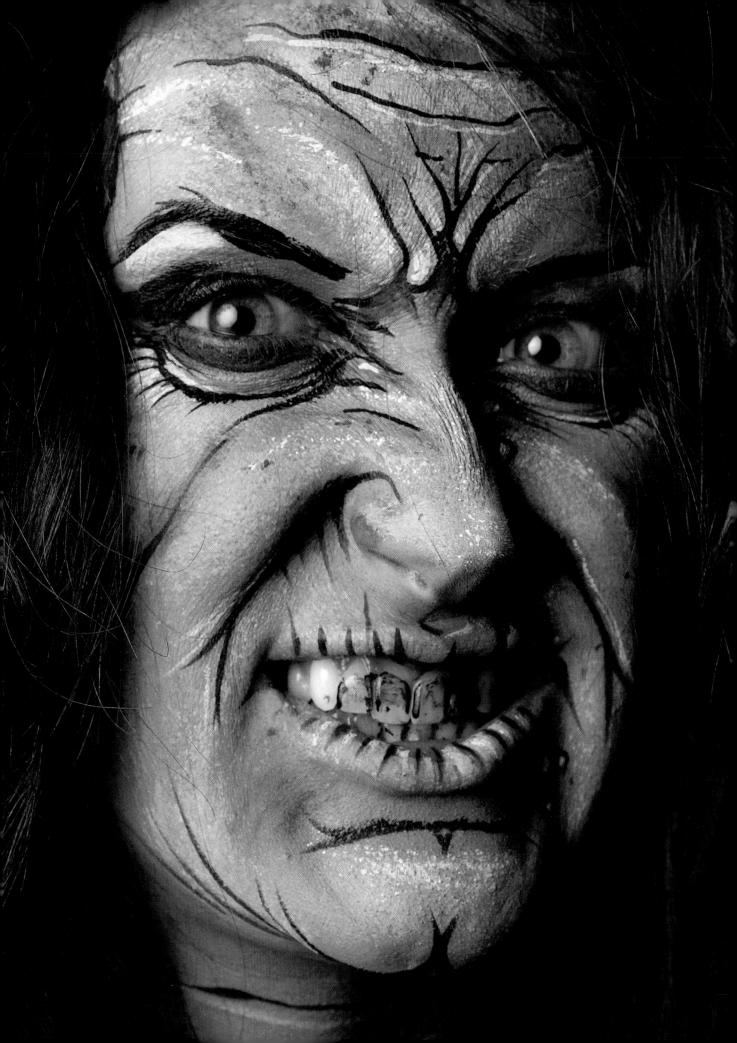

Witch

Apply a basecoat of pink to the face and neck using a sponge. Place off-white highlights on top of the pink with a sponge, stippling to suggest wrinkles on the forehead, cheeks, chin, and between the eyes. Apply off-white over the lips to create cracked lips.

Using a sponge and brown, shade in the areas between the highlights and sink in the eyes.

Stipple on white highlights along the brow, the tops of the wrinkles, and the tops of the cheekbones using a sponge. Also apply a mixture of purple and brown to deepen the shadows. Use the same color to add additional texture on the forehead with a sponge.

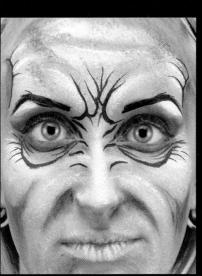

Begin detailing the face with a no. 3 round, adding black eyebrows and deep wrinkles around the eyes and bridge of the nose.

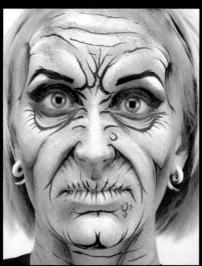

5 Using a no. 3 round and black wrinkle the lips, cheeks, chin and laugh lines with thin strokes. Add warts with scallop shapes, and place long horizontal lines on the throat to suggest neck wrinkles. Further develop wrinkles around the eyes using the same brush and color.

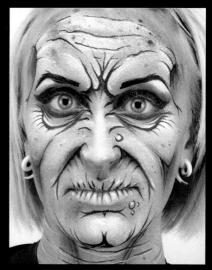

Add white highlights along the thin wrinkles on the face and neck using a no. 3 round. Use the same brush to add liver spots and freckles on the face with the purple and brown mixture.

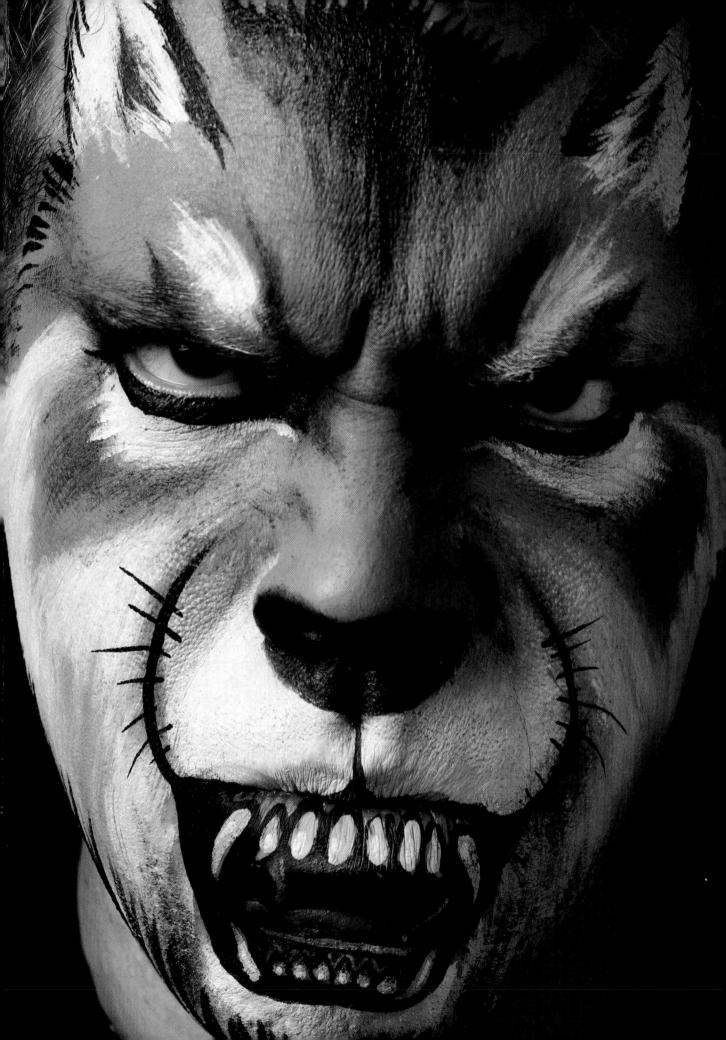

Wolf

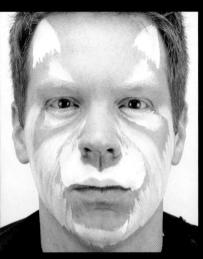

Apply a white basecoat around the mouth, under the eyes and on the forehead (to suggest the wolf's ears) using a sponge. Also stroke on white along the cheeks and jawline to indicate fur.

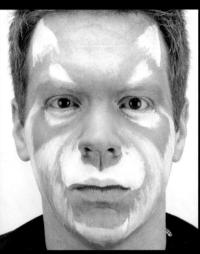

2 Sponge on gray in the negative spaces between the white, making sure you leave the areas beneath the mouth and nose free of color. Lightly dab gray over the white base on the cheeks and jaw to suggest the texture of fur.

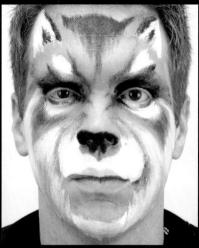

Shadow the face with black using a sponge. Add a fair amount of paint over the tops of the eyes, onto the brow, inside the ears and on the nostrils under the nose, as these should be the darkest areas. Then, go in lightly with dabs of black on the cheeks and ears to create fur accents.

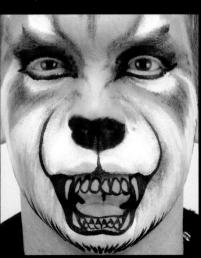

Use a no. 3 round and black to clean up the nose and to paint in the outlines of teeth. Place the top teeth along the bottom lip and the bottom teeth on the chin.

Continue to add details with a no. 3 round, partially filling in the mouth with black, leaving a space for the tongue. Then, line and shape

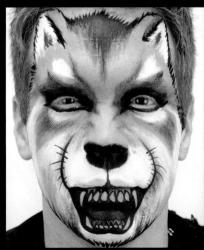

Finish the outline around the face, adding furry strokes of black with a no. 3 round. Define the ears and add thin whiskers along the edges of the muzzle using the same brush and color.

Fill in the tongue and gum line with a no. 3 round and some red. Then, go back in with your sponge loaded with black to shade the

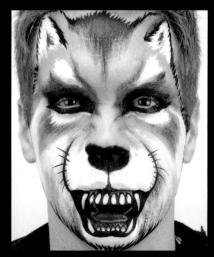

© Color in the teeth using a no. 3 round and off-white. Line the eyes with black and apply some black mascara.

Add white highlights on the ears and teeth, and around the eyes with a no. 3 round.

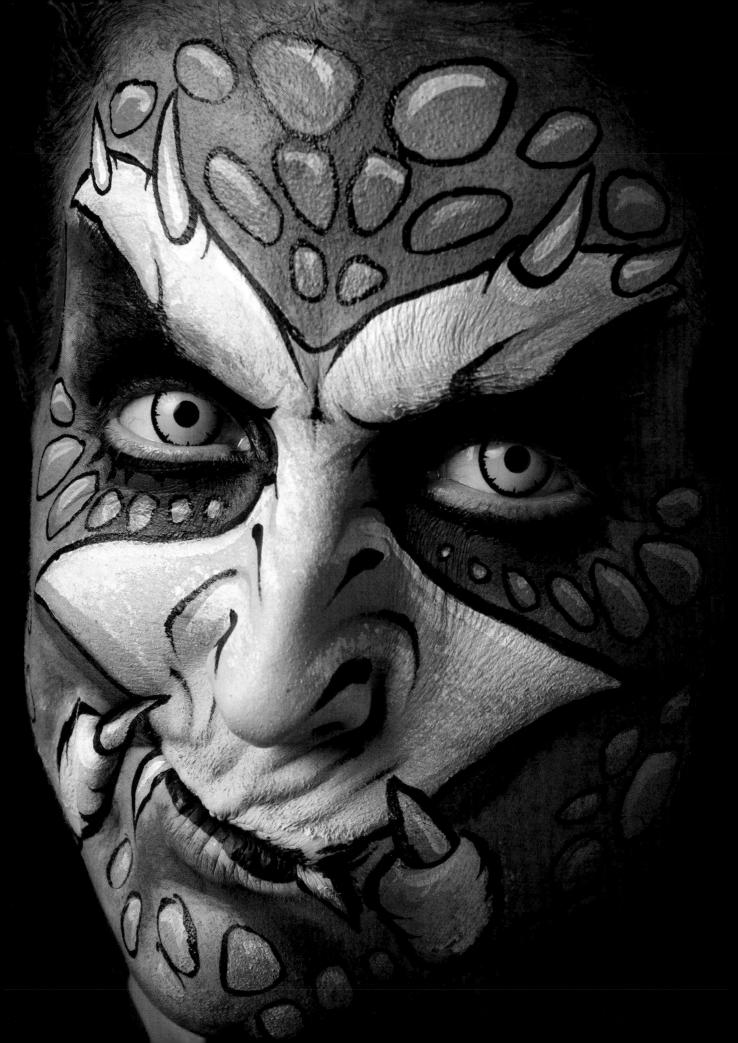

Xenomorph

Using a sponge, apply a basecoat of pastel blue to the area in the center of the face. Add a neon purple basecoat to the rest of the face.

If you use colored contacts for added effect (like the model here) have the model put the lenses in before you begin painting.

Stipple in white highlights on the blue areas using a sponge. Shade in the temples, around the eyes, and beneath the cheek flaps and the chin with a sponge and deep purple.

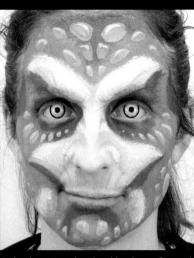

3 Apply spots using the side of a no. 3 round and a medium blue. Begin with larger spots on the forehead and work down to the chin and jawline. Use the same brush and color to add shading and wrinkles to the blue areas.

Use pastel blue and a no. 3 round to add highlights to the spots. Fill in the eye sockets with deep purple using the same brush.

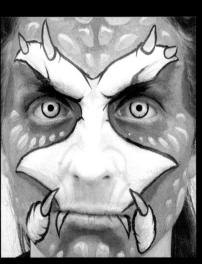

Apply goldenrod fangs and horns using a no. 3 round.

Outline the light blue area in the center of the face, working around the fangs and horns and adding wrinkles as your go, using your no. 3 round and black.

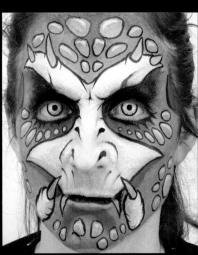

5 Outline the spots with thin black lines using a no. 3 round. Place details around the nose and add lashes beneath the eyes using the same brush and color. Also paint a thin black line between the lips.

Then, using a sponge, apply black on the evelids to recede the eyes.

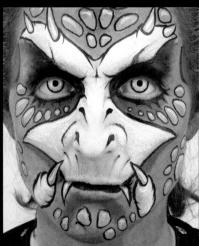

© Using your no. 3 round and white, add highlights to the fangs and horns, and additional linework to the blue center of the face.

Apply deep purple to the neck and ears using a sponge.

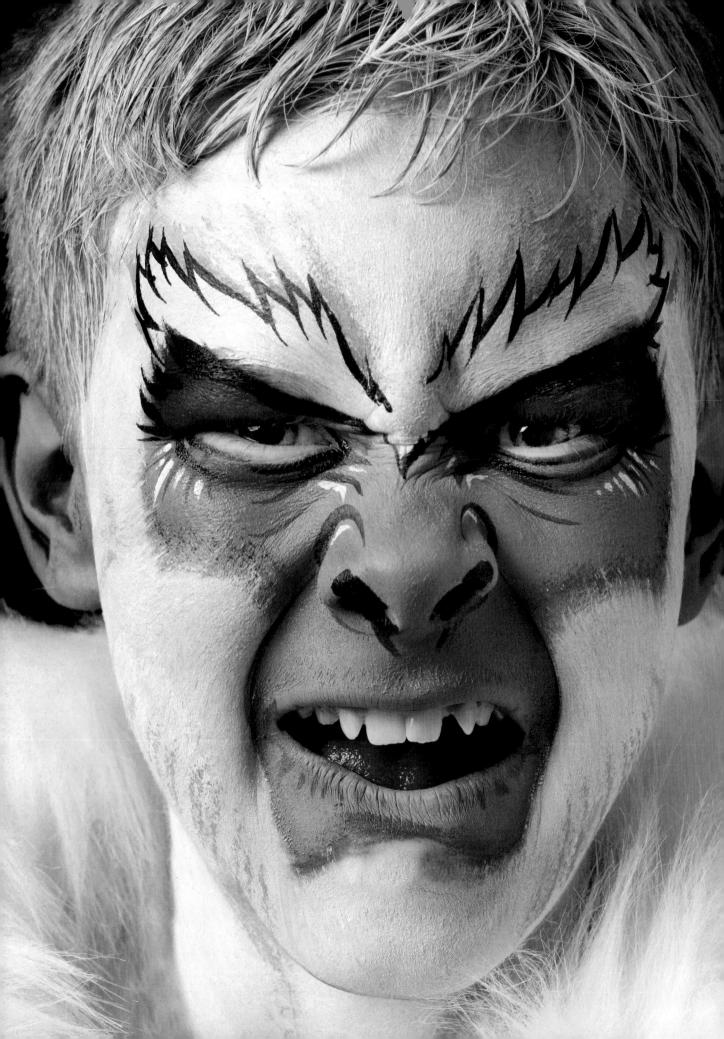

Yeti

Apply a light blue basecoat to the center of the face using a sponge. Start beneath the eyes, cover the nose, mouth and cheekbones, and avoid the jawline and chin.

Place shadows around the eyes and along the edges of the cheeks using a sponge and dark blue.

Add a white basecoat to the remaining areas of the face, as well as the neck and hair, using a sponge. Gently pull the sponge strokes upward into the blue to create rough edges along the cheeks.

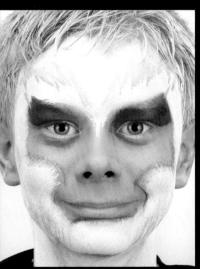

Sponge light blue onto the ears, and dab on the outlines of blue fur. Shadow the neck and beneath the chin with the same color.

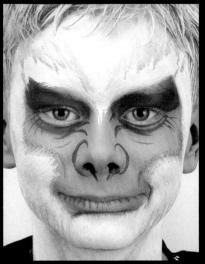

5 Using a no. 3 round and dark blue, add wrinkles around the eyes and nose, plus lines on the lips and slits under the nostrils. Fill in the recessed areas of the ears using the same brush and color.

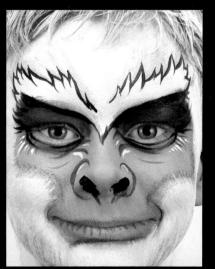

© Outline the furry brows, add details around the eyes, and fill in the nostrils using a no. 3 round and black.

Use the same brush to add white highlights on the wrinkles beneath the eyes and on the nose.

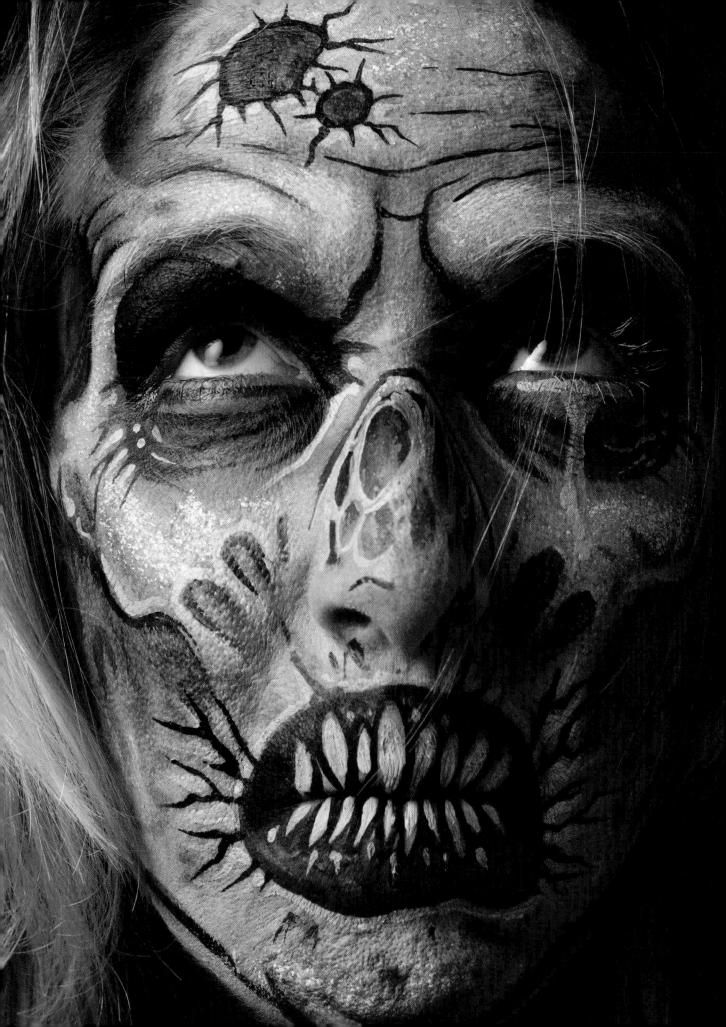

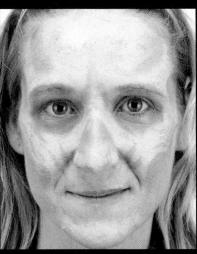

Apply a light flesh tone basecoat to the face using a sponge, first stroking on color and then stippling and dabbing to fill it in.

Use a sponge loaded with gray to create the skeletal form of the face. Shadow areas to sink them in and stipple a mottled pattern all over the face to break it up.

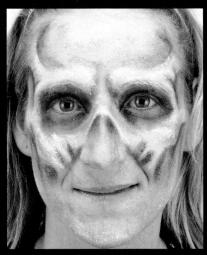

Deepen the shadows with black, applying color with the edge of a sponge in the darkest areas, then drag it down to blend.

Use the edge of a sponge to apply white highlights along the brim of the nose to make the nose bone pop. Then, stipple white along the brow and cheekbones for added effect.

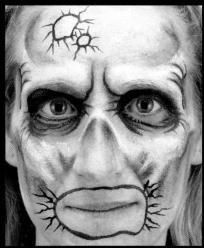

3 Use a no. 3 round and some black to outline the mouth to show where the lips have receded and cracked, and add two circles on the head to indicate wounds. Darken in the eyes, adding bags and wrinkles, using the same brush and color. Use the same technique to add wrinkles to the temples and brow line.

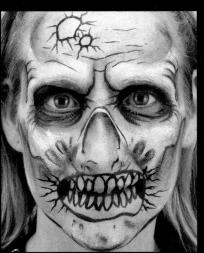

Using a no. 3 round, add black linework to the nasal cavity to help recede the area further. Sink in the muscles on the cheeks and cheekbones with teardrop shapes, and add some wrinkle lines on the forehead. Finally,

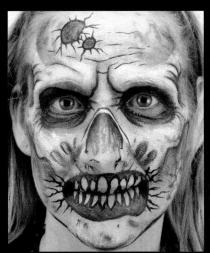

5 Use the side of a damp no. 3 round to mottle in the area surrounding the jaw and to drag color into the holes on the forehead.

Mix black with red and fill in the holes on the forehead and nose, inside the eyes and the

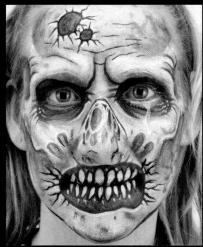

Highlight the teeth, gums and around the mouth using a no. 3 round and white. Highlight the rest of the face structure with a light flesh tone, ensuring that the highlights don't get too bright.

INDEX

A	D	
Alien, 72–73	Dimension, 17, 23, 39	line, 56–57
Allergies, paint, 8	Dinosaur. See T-Rex	placing, 111
Animals	Dracula, 80-81	stacking, 23, 77
bat, 40-41	Dragon, 82–83	stippled, 49
birds, 20-21	Drips	Hinges, 106–107
bunny, 22–23	blood, 79–81	Horns, 66-67, 76-77, 86-87, 120-121
butterfly, 24–25	cleaning up, 15	Horse. See Unicorn
cat, 28–29	eye, 124–125	Hyde, Mr., 94–97
giraffe, 38–39	facial, 32–33	grant than the major to the
insect, 90–91		
jaguar, 42–43	Environment of the state of the	Insects, 24–25, 90–91
lion, 46-47	Ears, 58-59, 68-69	Inspiration, 7
monkey, 48–49	Edges, cleaning up, 15, 21	
piglet, 54–55	Eyebrows, 44-45	J
puppy, 58–59	clown, 32–33	Jack-o'-lantern, 92–93
tiger, 64–65	Goth, 88–89	Jaguar, 42–43
unicorn, 66–67	painted, 48-49, 94, 96-97, 122-123	
wolf, 118–119	Eyelashes, 14, 88–89, 120–121	K
zebra, 68–69	Eyes, 78–79	Knight, 44–45
See also Beast; Reptile; Werewolf	cute, 14, 66–67	
Antennae, 24–25, 90–91	mean, 14	
	shading, 80–81	Leaves, 31, 36–37
B	sunken, 44–45, 48–49	Linework, 11–12
Baby wipes, 8-9	wrinkly, 44–45 (See also Wrinkles, eye)	decorative, 62–63
Baby's breath, 36–37		eye, 88–89
Bandages, 98–101	F	outlining, 17
Bat, 40–41	Feathers	outlining, white, 32–33
Beak, 20-21	blue jay, 20–21	thin-to-thick-to-thin, 12, 16
Beard, 16	peacock, 52–53	Lion, 46–47
Beast, 76–77	Fire demon, 84–85	Lips
Bee, 30–31	Fish, kissing, 34–35	cracked, 116–117, 124–125
Birds	Flames, 74–75, 83–85	painting, 15, 73
blue jay, 20–21	Flares, 74–75	Liver spots, 117
peacock, 52–53	Flowers, 30–31, 36–37	M
Blending, 9	Freckles, 16	
Blood, 16	Fur, 10–11, 76–77	Mask, bad girl, 74–75
drips, 79–81	feline, 28–29, 42–43, 46–47, 64–65	Materials, 8–9
Blue jay, 20–21	wolf, 118–119	Metal, 44–45, 78–79, 106–107
Brushes, 8	wolf, were-, 112–113	Mistakes, erasing, 15
Bunny, 22–23	G	Monkey, 48–49
Butterfly, 24–25		Monsters, 16 Moon, 50–51
C	Gargoyle, 86–87 Giraffe, 38–39	Moustache, 16
0 00 07	01711 0 40	Mummy, 98–101
Car, 26–27 Carrot, 22–23	Gitter, 8, 16 Goth girl, 88–89	Muscle patterns, 10
Cat, 28–29	Grass, 38–39	Muzzles
Chameleon, 30–31	Grooves, 92–93	feline, 28–29, 42–43, 46–47, 64–65
Cloud, 60–61	4100703, 32 30	puppy, 58–59
Clown, 32–33	H	wolf, 118–119
Color	Hair	zebra, 68–69
blending, 10–11	facial, 10, 44–45	See also Snout
dragging, 11	monkey, 48–49	
lifting, 15, 103	rabbit, 22–23	N
reflected, 17	Hand sanitizer, 8	Night sky, 50–51
Color wheel, 9	Helmets, 44–45, 102–103	
Contact lenses, colored, 102–103, 120–121	Highlights, 9–10, 17	0
Cotton swabs, 8, 15	bird, 20–21	Orc, 102–103
Cracks, facial, 92–93	color in, 9	Outlining, 17
Crown, 56–57	eye, 14	
Cyborg, 78–79		

The Wolfe brothers with the IMPACT Books' studio crew.

Resources

You can find anything you need on the Internet. Type in "face painting supplies." There are face painting forums to get advice as well. Your local art supply store may have all you need, too.

If all else fails, email us at info@eviltwinfx.com.

Paint, 8 cakes, 9 removing, 13 Painting kits, 8–9 Piglet, 54–55 Princess, 56–57 Puppy, 58–59

Rabbit. See Bunny Rainbow, 60-61 Raindrops, 13 Reptile, 104-105 See also Chameleon Rivets, 44-45, 102-103, 106-107 Robot, 106-107 Rust effect, 103

S

Scales, 82-83, 104-105 Shading, 17 Skeleton, 108-109 See also Zombie Skin, cut and blemished, 15 See also Blood; Liver spots; Sores, festering; Warts; Wounds Skull. See Skeleton Sky, night, 50-51 Snarl, 94-97 Sores, festering, 97 Spider, 114-115

Sponge work, 8–11 Stars, 12, 16, 50–51, 56–57, 60–61, 66–67

spattered, 72-73 Stippling, 10 Stone texture, 87 Striping, 64–65, 68–69, 82–83 Strokes, 10–11 Sunset, 51 Swirl design, 62–63 Swirls and curls, 13, 56–57

Teardrops, 13, 56-57, 62-67 Techniques, 10–17 brush, 12–14 color, blending, 10-11 color, dragging, 11 cotton swab, 15 crosshatch, 98, 101 dots, adding, 11, 15 fur, 10-11 glitter, 16 line, 11 line, thin-to-thick-thin, 12, 16 lip, 15 mottling, 16, 100, 125 painting, 12–14 raindrops, 13 spattering, 16, 81 sponge, 10-11 sponge, dry, 99 stars, 12, 16 stippling, 10 stroke, circular, 10 swirls and curls, 13 teardrops, 13, 56-57, 62-67 Wash, 16
See also under specific technique or effect
Texture, 10–11, 16
Tiger, 64–65
Tongues, 58–59, 110–111, 118–119
T-rex, 110–111

Unicorn, 66-67

Values, 9 Veins, 81, 89

W

Warts, 116-117 Warts, 116–117
Water bubbles, 32–35
Werewolf, 112–113
Whisker spots, 58–59
Whiskers, 97
bunny, 22–23
cat, 28–29, 42–43, 46–47 Widow's peak, 47, 64-65 Wings bat, 40-41 bird, 20-21 butterfly, 24-25 unicorn, 66-67 Witch, 116-117 Wounds, 79, 124–125 Wrinkles, 116–117 eye, 44–45, 48–49, 77, 80–83, 110–111, 122–123 facial, 94, 97, 104-105, 124-125 lip, 110-111 nose, 48–49, 77, 82–83, 112–113 See also Cracks, facial

X

Xenomorph, 120-121

Yeti, 122-123

Z

Zebra, 68-69 Zombie, 124–125 skin, 16

IDEAS. INSTRUCTION. INSPIRATION.

THESE BOOKS AND OTHER FINE **IMPACT** TITLES ARE AVAILABLE AT YOUR LOCAL FINE ART RETAILER, BOOKSTORE OR ONLINE SUPPLIER.

ISBN-13: 978-1-60061-819-2 Z5353 • paperback • 176 pages

ISBN 13: 978-1-60061-922-9 Z5977 • DVD running time: 55 minutes

ISBN-13: 978-1-60061-071-4 Z1818 • paperback • 128 pages

Visit our website at www.impact-books.com

- · Connect with other artists
- Get the latest in comic, fantasy, sci-fi art and pop art
- Special deals on your favorite artists' books

VISIT WWW.ARTISTSNETWORK.COM TO SIGN UP FOR OUR FREE E-NEWSLETTER AND RECEIVE A FREE GIFT.